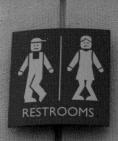

RESTROOMS
D069100G
FIRST AID
CHOKIN

Señoritas

TOILET
여자 WOMEN

RESTROOM

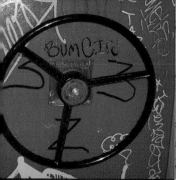
BUMCICO

RESTROOM

MEN'S ROOM
AROUND THE CORNER!
BACK HERE!

RESTROOM

MEN/WOMEN

Bathroom Graffiti

Mark Ferem

MARK BATTY PUBLISHER
NEW YORK CITY

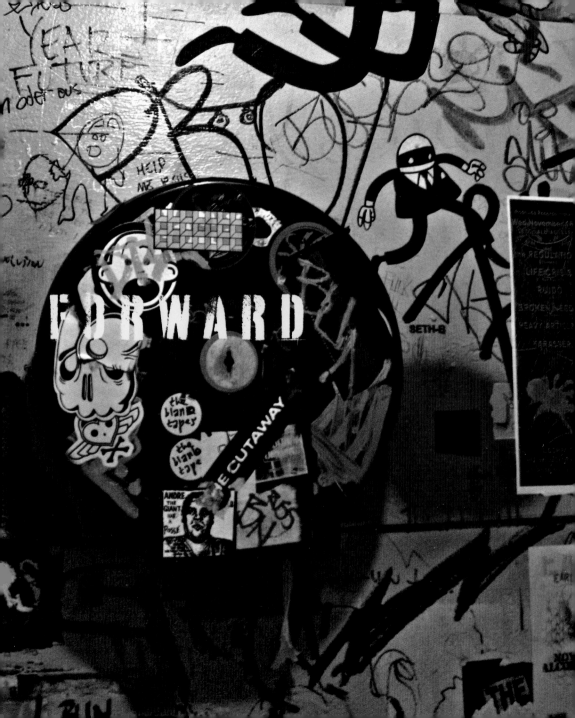

For a Good Time Call...

by Amir H. Fallah

How many times have you sat in a bathroom stall bored out of your mind while you wait for nature to take its course? You sit there counting tiles on the floor until out of the corner of your eye streaks of color, or a few scribbled words, catch your attention. You lean closer to look. Eureka! A couple minutes of stimulation to combat the semi-sanitary dungeon of boredom known as the public restroom.

Usually the scrawls and doodles in the bathrooms don't reveal anything profound or life altering. They are simple messages and images written and drawn anonymously in the safety of the bathroom stall. People feel freed once they step into these spaces, compelled to share their most intimate, goofy and dirty thoughts with the next occupant. My favorite bathroom graffiti are the ones that make no sense. The drawings that capture my attention and ask me to make sense of the nonsense that someone spent a precious 30 seconds to execute.

Like the doodle of a whale and bunny having sex. This is about as absurd as an image gets. What is a whale doing out of the water? How did he find a little bunny to make sweet, sweet love to? How can a whale even have sex with a bunny? I'm no doctor but I'm sure this would require nothing short of a biological miracle. Finally, who on god's earth drew this image and where can I purchase a signed copy? I have no idea what this image is supposed to communicate or express. All I know is that it made me crack up when I saw it, helping pass time while I did the one task that I've done a million times.

Other favorites include quotations such as "give peace a chance" scrawled by optimistic hippie types looking to change the world one stall at a time. Somehow I'm not sure if the bathroom is the right place to end wars, but I guess anywhere would be a good place to start at this point.

Last but not least is my absolute favorite of all time, the infamous "call _ _ _ - _ _ _ _ _ for a good _ _ _ _." You just can't beat this. It's a bathroom classic and if there were a bathroom graffiti hall of fame this surely would make it in on opening day. Anyone can execute this one and most people have. It's a great way to get even with a cheating ex- girlfriend/boyfriend, or your boss, or your drunk friend that repeatedly spills beer all over your brand new pale-yellow satin suit. I've never called one of these numbers but every time I sit in a stall I wonder what the voice would say on the other end. Would someone really pick up and give me a good time? I'd say ten out of ten times you'll get an angry confused person on the other end of the line screaming their head off because you're the 100th person to call. Or you never know, maybe you'd have a great time.

One of these days, if I don't have a pen or marker I may contribute to bathroom graffiti by placing that call. That's the real magic of the pictures in this book. They capture moments in time where individuals left their marks for the rest of us to see, binding us all together by the simple fact that we all have to go to the bathroom. We may not find some people's sentiments funny, or smart, or polite, or logical, but it's in our own power to make those choices, and that's what *Bathroom Graffiti* celebrates: the voice of the individual to be heard, even in the most private moments.

*Amir H. Fallah is the founder of the magazine **Beautiful Decay**.*

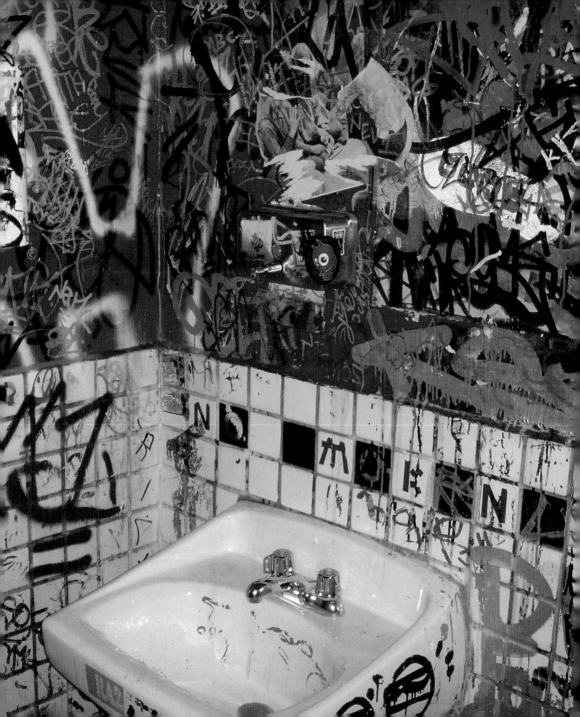

PREFACE

What started as a hobby quickly became a fascination.

In 1994, as time and money allowed I began documenting the words and images of restroom graffiti, which lead to the Latrinalia Project. I thought I could gain a better understanding of what brings these messages into being. If there is anything that I've learned from my years of documenting latrinalia is that the graffiti says a lot more about us than we realize.

As a photo-essay, *Bathroom Graffiti* allows the initiate to gain a better understanding of its value as folklore and a reflection of human culture. Bathroom graffiti is not so much a chicken soup for the soul as it is a seafood gumbo for the mind.

It's only now that I look back and wonder as to what brought me to this place of ritual and culture. It becomes clearer; the pieces come together. I remember as a child when my grandmother would lead us in procession in the dark around the house through every room, each of us holding candles and singing "Ave Maria." And those Sundays where she and my mom would take us to the cemetery to have a picnic

while she cleaned the gravestones and placed flowers for those relatives and friends who had long since detached themselves from this mortal coil. It's the power of these memories that still maintain a place on my mental altar. My grandmother believed that in honoring the past we remain connected to the present. What she long knew, I didn't fully appreciate until I made trips to places like Stonehenge, the Vatican, and later Tixkopo for Dia de los Muertos and also to Chichen Itza for the Vernal Equinox, the ruins of the Ancient Mayan Dynasty. I realized what ritual and culture have to offer – this umbilical cord that connects us all to the understanding of who we are, what we love, believe and fear.

So when I look at bathroom graffiti with it's simplicity and open-heartedness I see an expression of a modern day cultural rite. I was impressed by the Mayan's desire to keep account of time, the days, the years and the mystery that filled them. It's what compelled me to document these bathroom graffiti photographs. That somehow every moment is connected to the next and each one contains something of the spirit in which it was written.

Bathroom graffiti documents the words and images that tattoo restroom walls across the Americas and abroad, moments that disclose the content between private thought and public space. The words and images of bathroom graffiti are scattered with emotional debris that reflects the mood of a generation. Bathroom graffiti's scatological humor and sage rants not only hold up the mirror but shatter it across our collective cranium, that we might remain open to the spontaneity of life and the random firing neurons that make our visit worthwhile.

For beauty is nothing but the beginning of terror, which we are still just able to endure,
and we are so awed because it serenely disdains to annihilate us. Every angel is terrifying.
–Ranier Maria Rilke

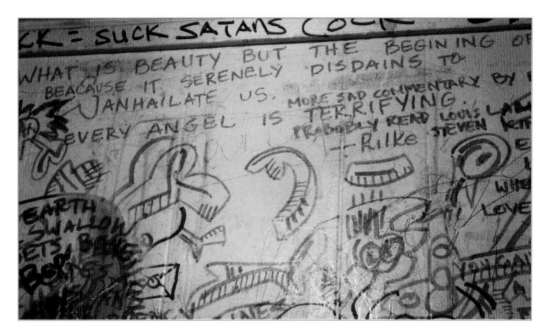

In 1994, I saw this in a men's restroom at Lola's, a dive bar in Houston, Texas. This was the first piece of latrinalia that caught my attention. At first glance it seemed meaningless, but in the context of the environment, the passage opened itself up to an interpretation that somehow gave it another layer. Restroom graffiti had always been invisible to me until then. Later, as I encountered more pieces of latrinalia I felt the words and images, the shapes of the thoughts and forms that the authors and artists conveyed were in a sense landmarks and mileposts to the remains of a moment, a subtext to the human spirit and ritual of human culture.

TABLE OF CONTENTS

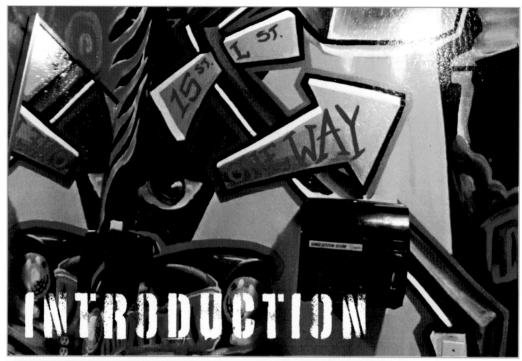

INTRODUCTION

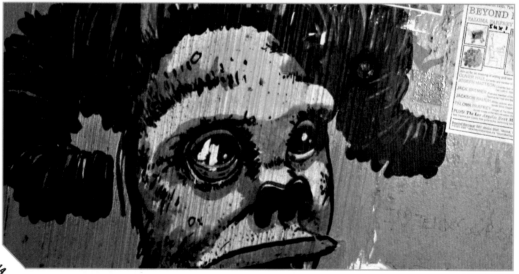

The Wall

Bathroom Graffiti is an investigation of self-expression that maintains a narrative of cultural and emotional authenticity. The aesthetics of these messages and images reflect the passion and mood of society in transition, and for those unfamiliar with the cultural dynamic of bathroom graffiti, this is a welcome mat of cultural exchange. Bathroom graffiti records the trials of the day-to-day life of the average and not so average person. Though some may dismiss bathroom graffiti as an act of vandalism, many owners of businesses leave it up, a nod to its cultural import. The thrust of bathroom graffiti doesn't advocate vandalism or the freedom from moral restraints, it does however symbolize a freedom from mental constraints. As an art form it's always on the verge, in constant motion, organic and ever evolving; it is the art of the people, by the people, for the people. It pushes against a society that is constantly pulling, which may be one of the sources of its tension. Bathroom graffiti shines an unfiltered light on an anonymous aspect of our world, a signpost of sorts with scatterd scrawlings framed only by the borders of the mind.

Walls can be symbols of containment, or safety; they can be used as borders, pscho-logical barriers, or symbols of unity. The bathroom wall becomes the metaphor for sociopolitcal issues and cultural rites of passage. In the world of graffiti, bathroom graffiti is not so much street art or throw-ups, but more like regurgitations, the result of a world infiltrated by global multi-media carpet bombing. The restroom has become

a sanctuary, or bomb shelter, a place to download the digital dust gathered from the daily consumption of a hi-def reality. Latrinalists believe that there is no ascension without dissension. From the street artist to the anti-graffiti squads to the latrinalia and the spectators, they all participate in the battle between free speech and censorship. Bathroom graffiti is the mortar that holds the wall together. It's for the people to decide if it's an issue of unity or one of division, to be torn down or maintained. In the next few chapters we'll take a look at what is buried in the emotional debris of bathroom graffiti.

Today, the walls of women, unisex and men's restrooms are places where neurons are likely to find themselves splattered on walls like butterflies on the grill of a passing truck. From rainman-like rants to philosophers of emotional porn, bathroom graffiti is a common form of communication art. Though the dynamics of restroom graffiti have no motivation other than to voice one's opinion it has an ability to make contact on many different levels with viewers. With an occasional mark or signature, the voices of bathroom graffiti celebrate the form's anonymity and spontaneity. These bathroom artists and restroom sages are in the struggle for art, between emotion and reason.

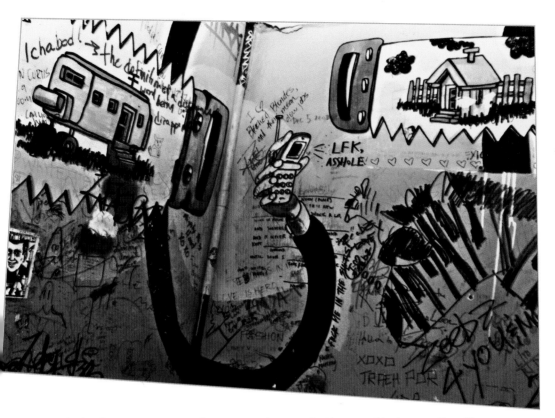

And in these times, a voice of reason may be armed with a can of krylon or a Sharpie.

Bathroom Graffiti is about acknowledging the existence of these anonymous moments, the authors and artists who found it in themselves to speak out and heave the slings and arrows of societal conditioning. It could be said that the philosophy of bathroom graffiti may not be in the words or images, but in the rebellion they represent. Whether the restroom graffiti is a knee-jerk reaction to our collective malaise or the process of our psyche healing, it wills itself into existence. And on some level that may be validation enough.

The rituals of human culture give us a different perspective of ourselves and preceived social order. These differences connect us to one another and allow us to appreciate the things we have in common.

Graffiti has tattooed the walls of lavatories, latrines and loos for centuries. Its roots trace back to ancient storytellers and their narratives of daily events told through carvings, etchings and paintings. Some documented celestial occurrences such as eclipses or comets while others lent their talents to the pathos of the day. This piece of graffiti excavated from a bathhouse in the ruins of Pompeii, Italy, can be paraphrased: "Baths, wine and sex destroy our bodies. But only baths, wine and sex make life worth living!" It's interesting to note how some of the themes of today's restroom graffiti are not so different.

From 1904-1913, ethnologist Friedrich S. Krauss of Vienna, Austria, produced the journal "Anthropophyteia." It was dedicated to the publication of folkloric tales, erotic folklore and other materials on sexology. It was in the journal that Krauss published some of the first research on toilet inscriptions and a collection of restroom graffiti. By 1913, however, he ceased publication and was financially bankrupted due to various obscenity trials.

In 1935, A.W. Read, an American etymologist English-language scholar compiled the first in-depth account of American bathroom graffiti. While on a trip through western North America in the summer of 1928, the large quantity of graffiti he found while using a number of public restrooms piqued his interest. Inspired by varied content and styles, Read put together *Lexical Evidence from Epigraphy in Western North America: a Glossarial Study of the Low Element in the English Vocabulary*. The book contained material unacceptable for publication at the time in America and was later published in Paris in 1935.

Here are a couple examples:

I have a girl in Indiana, She'd like to play with my banana, she can sing and can dance, And she has whiskers in her pants.
–Shady Camp, near Brady, Nebraska. August 24th 1928.

By the funny display of wit, It looked like Shakespear had been here to shit.
–Norris Junction Camp, Yellowstone National Park, August 14th 1928.

The late Alan Dundes, professor of anthropology and folklore at the University of California at Berkeley, coined the term "Latrinalia," as he preferred it to the term "shit house poetry." Dundes posited daring, neo-Freudian analysis of graffiti content in his article for the Krober Anthropological Society Papers in 1966, "Here I Sit: A Study of American Latrinalia." Other such papers were delivered, but were often censored due to their racy nature. Dundes challenged such "academic resistance" to these pursuits near and dear to his heart by identifying a double standard. It was perfectly permissible to investigate the graffiti of ancient and classical cultures of the past, but it was not acceptable to study the graffiti of contemporary cultures. Times have changed since then, and through the years all the social scientists that have studied bathroom graffiti have had as many reasons for its existence as there are writers and artists.

As empires come and go and dynasties collapse, the myths and folklore are what will live on after the walls fade and crumble. It's the words, images and stories that will survive. And when the cultural anthropologists of the future ask, What were they thinking? How did they feel? What did they care about? The cultural artifacts of latrinalia will give them a glimpse of the humor, the beauty and pain of civilization at the turn of the twenty-first century.

Have humans always had the need to leave a mark? Or is it the oppression of ancestral conditioning that pushes these images and syllables onto the bathroom walls? Bathroom graffiti is created by ordinary people, it's not high art or literature in the elitist sense of these terms, but an expression of people's inner feelings and therefore as expressive as most professional works of art. It consists of everyday life that we can all relate to. And in the end isn't that what we're all trying to do?

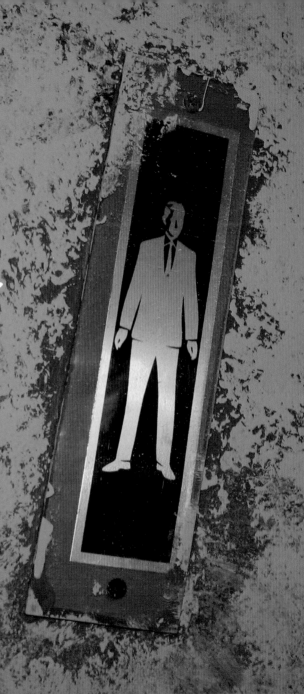

CHAPTER 1:

MEN'S ROOM

It's All in the Head

Our cerebral predisposition for latrinalia leads us down a well-traveled road, or as a French poet put it, "the muddy road entices."

It's down this muddy road that we find the place of kings; it's known to be the throne to some, in effect the modern primitive equivalent of our bipedal cousin's cave. If you throw in a newspaper or magazine you may never see us again. Aboard seafaring vessels the bathroom is called the "head." The term comes from the days of sailing ships where the crew relieved themselves of their porridge, located up front on either side of the figurehead, down wind from the rest of the crew. Only the captain had his private toilet near his quarters, below the poop deck, of course. The bathroom has long been known for its healing properties and as man's ultimate place of rest to ponder world events, or the sports page. It's every man's fallout shelter, the cubicle man's refuge where he reminds himself that he is still human. And at some point it's where one might look to the blank stall wall, pull out a company issued Sharpie and with the rush of a mental colonic pen his brief escape.

In my excursions through the world of bathrooms I found, surprisingly, that graffiti in men's restrooms on the whole averaged a bit less than in women's restrooms. What does that say about men? Probably nothing other than women had a pen or marker at the ready. But just off the beaten path, where the cranium meets the stucco one can find men's rooms crushed with anonymous moments of creative expression. We are conditioned to the norm that it's not okay to write on walls, which is why some establishments put up chalkboards. Because bathroom graffiti is not a sanctioned form of art or communication, most latrinalists might maintain a sense of anonymity to avoid the potential repercussions of writing on bathroom walls.

There is a plethora of tags in men's bathrooms, come to think of it women rarely tag. At times it appears to be territorial, these stylized monikers, name treatments that are almost the equivalent to the famous "Kilroy was here," if not more personalized. It's the rookies' playground, practicing their styles before taking it to the streets. In the battle for public space the bathroom must be the trenches of the front line. It's here that the men's shamanistic shape-shifting tendencies take on the sweat lodge, vision quest rites of passage, where men become more contemplative, sometimes lewd, obnoxious, playful and surprisingly pensive. Latrinalists live in the idea that if you give a man a fish you feed him for a day, if you give him a wide tip marker he can live forever, immortalized for the moment, or at least until a new coat of paint arrives.

Considering the history of bathroom graffiti one can argue the reason for it's being, as a cultural artifact or a medium of expression. It is difficult to discount the voice, the creative energy that wills itself into existence. We listen in these moments of silence, between the ruckus and chaos of our daily lives. These latrinalists take pause to breathe, to remind us of what's genetically embedded in our nature, our birth right to be human.

Overall, men's bathrooms, from bars to colleges, offer a wide spectrum of graffiti, strategically placed with voices ranging from subversive quatrains to waxing on life's

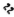

absurdities. For some latrinalists, placement is taken into consideration in delivering their message. Like this little beauty from Che Café in San Diego, "Freud Sucks," written in reverse on a paper towel dispenser so that reading it in the mirror, it appears properly. And some are just pure genius: "If Pro is Progress, what is Con?" There are other ways to peer into the heart of man besides a table saw through the breast plate. This particular comment may be an attempt to introduce man to his higher self: "God is a weak man's salvation." (Page 25) This was on the ceiling next to the light bulb of

the legendary Al's Bar in downtown Los Angeles. These comments call into question humanity's obsession with displaced accountability. Is humanity waiting for the (pick your deity) to come down from the heavens to save us from ourselves? How many deities does it take to blame for the state of humanity's disposition? As our culture conforms to its own rebellion, we turn to the primal, primitive, the ritualistic, in the hope that somehow our ancestors will connect us to this mystery of the mist. Are we the ones we have been waiting for?

Unadulterated and uncensored, it could just be the writing on the wall but it's proof that at least the neurons are still firing, that the youth are not just pondering today's most popular fruit flavored condom, the hottest spring break destinations, or attending the next fast food gastro-bacchanalian orgy. There are signs of intelligent life wondering about the wizard behind the curtain, acknowledging that something is not quite right with the world and demanding accountability. Bathroom graffiti is just one of the beacons calling attention to a pandemic spiritual disconnect. The latrinalists of today may just be tapping into that additional fifty percent of brain mass we happened to come by so long ago.

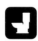

GOD
IS
A WEAK
MINDS
SALVATION

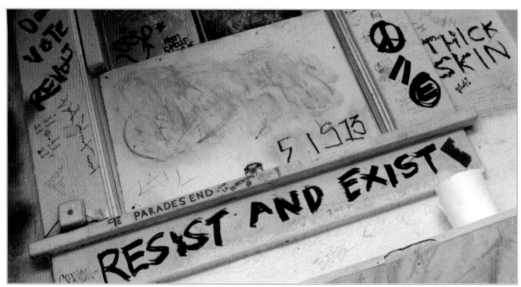

 TOI RESTAURANT, HOLLYWOOD, CA

CALARTS, VALAENCIA, CA

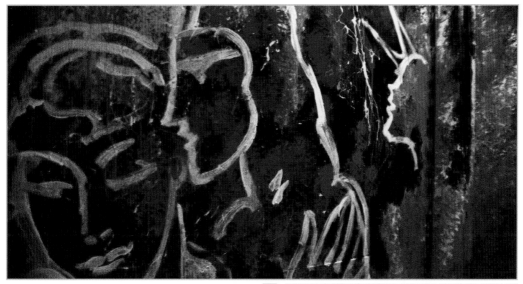

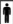 MOLLY'S CASINA, NEW ORLEANS, LA

LIL JOYS BAR, ECHO PARK, CA

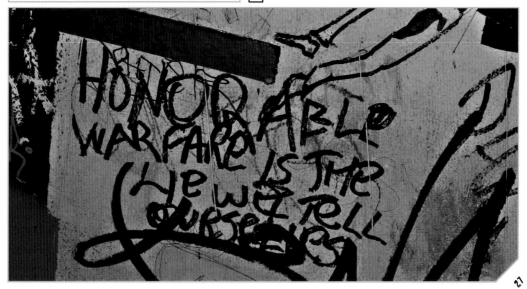

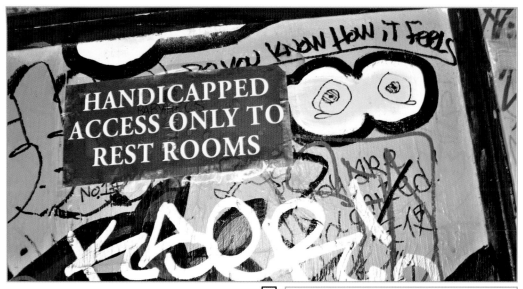

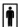 MARS BAR, NEW YORK CITY, NY

BOWERY POETRY CLUB, NEW YORK CITY, NY

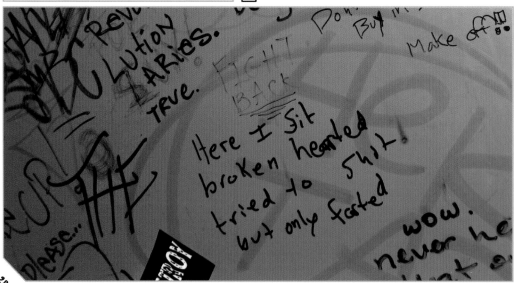

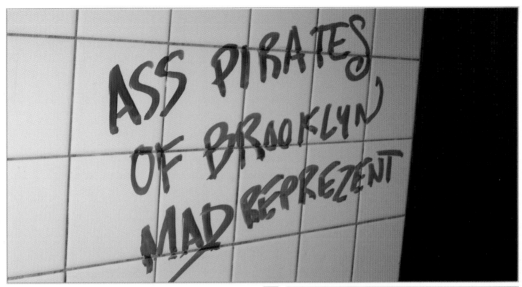

 ABILENE, BROOKLYN, NY

HIGHLAND GROUNDS, LOS ANGELES, CA

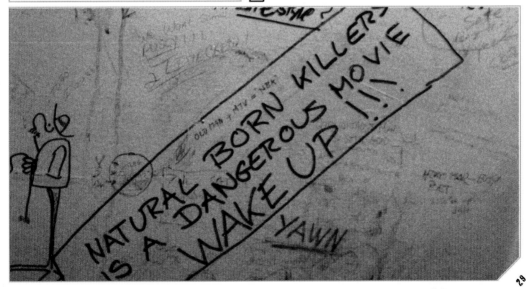

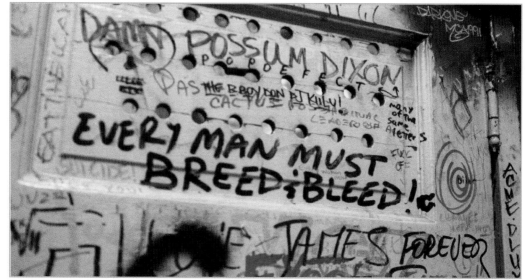

 AL'S BAR, LOS ANGELES, CA

TOI RESTAURANT, SANTA MONICA, CA

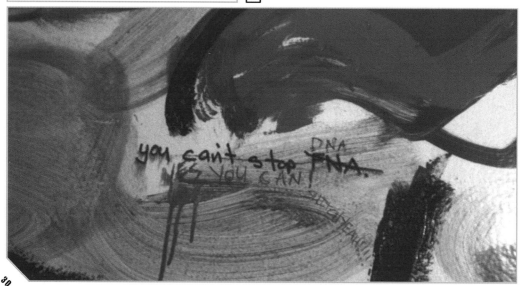

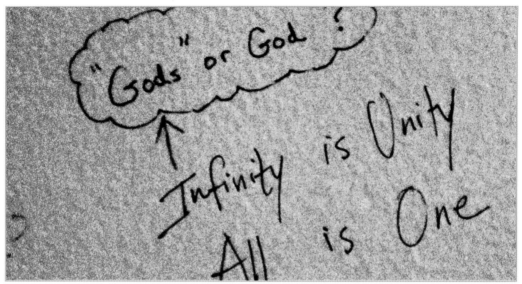

 EJ'S COFFEE & TEA CO, ALBUQUERQUE, NM

DON ARMANDO'S CABANAS, TULUM, MEXICO

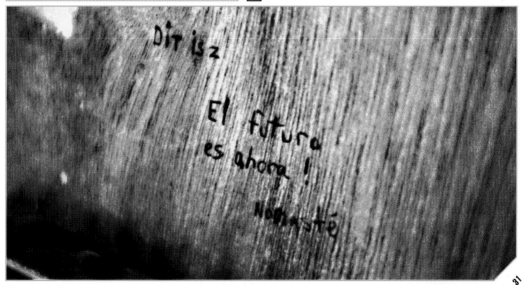

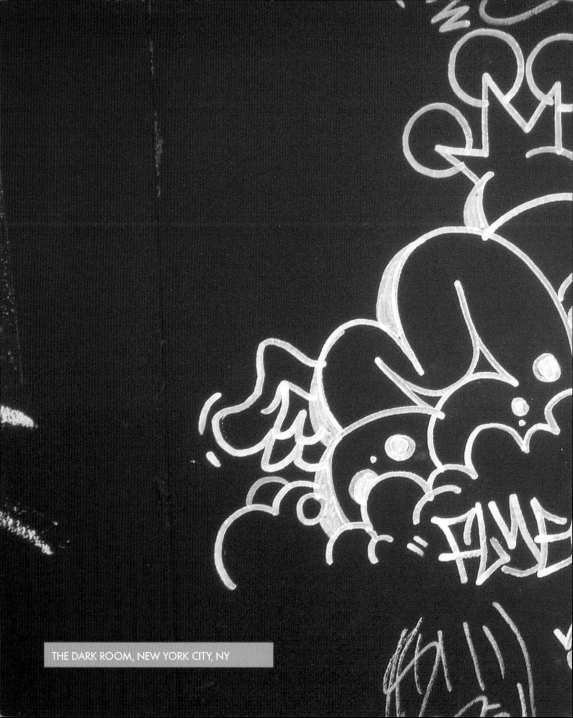

THE DARK ROOM, NEW YORK CITY, NY

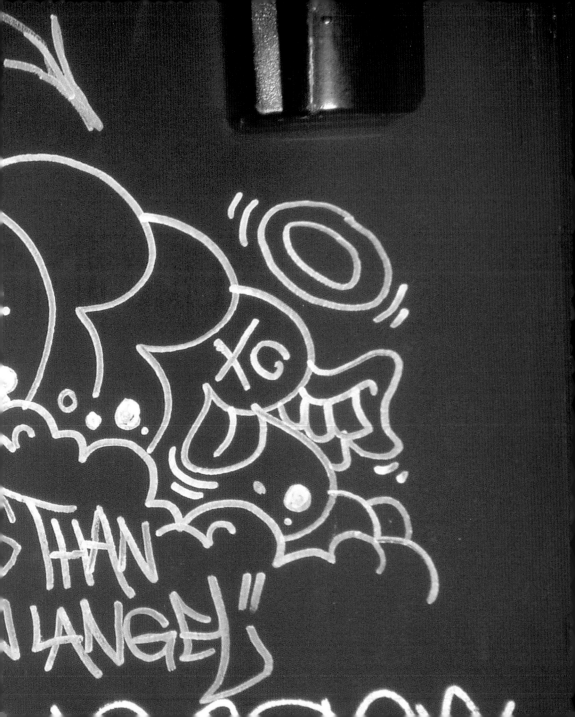

 THE DARK ROOM, NEW YORK CITY, NY

MOTOR CITY, NEW YORK CITY, NY

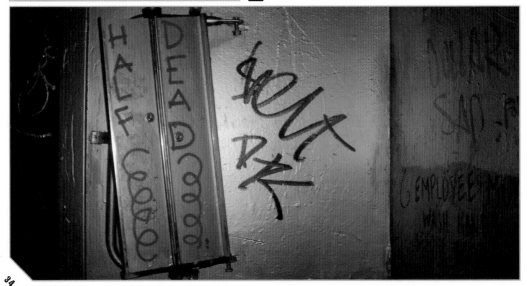

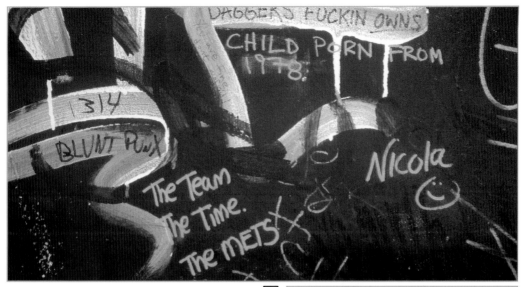

 THE DARK ROOM, NEW YORK CITY, NY

MARS BAR NEW YORK CITY, NY

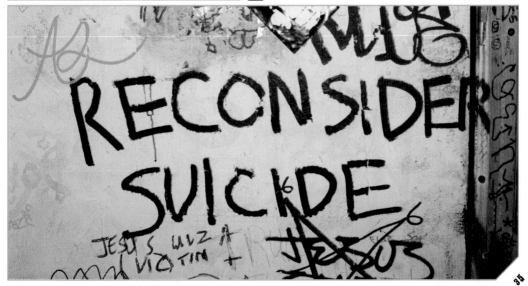

JUNE 12, 1991 AL BUNDY RU

...IT OVER HERE BABY POP. AND LET ALL THE FLY SKINNY'S FILL THE BEAT- AN DROP ↑

DREAM, ROLL, DREAM,
DREAM, ROLL, ROLL, M. it's all words.
FREE MONEY!! words for you.

NOTHIN...
WORLD.

RE.: WAKE. kiss them.
BREJOE
LO!

HEPHALUMP.
BISQUITS OR
PECT LEMIN CAKPEG

IT'S AN EM... CH...

WELL I HAVE NEVER BEE...

CONCH BACK HOME.

EATSHIT

THE ANGELS CRY

employees Must wash hair

CHEAP MONDAYS AT CAMP

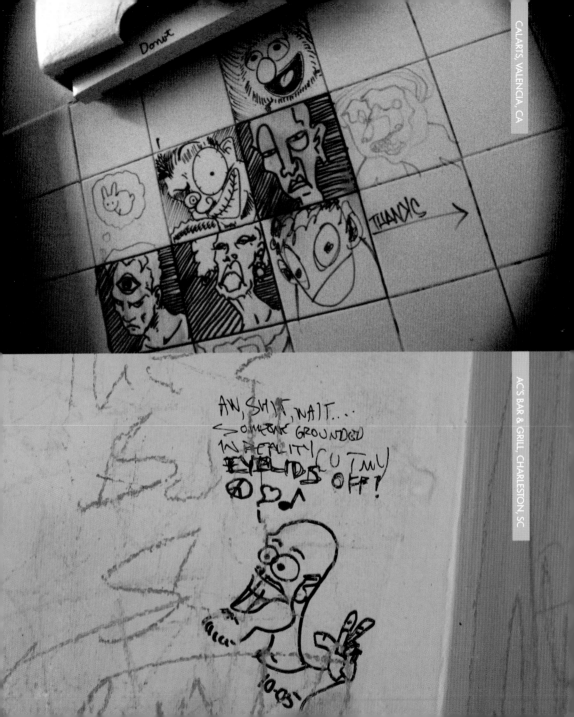

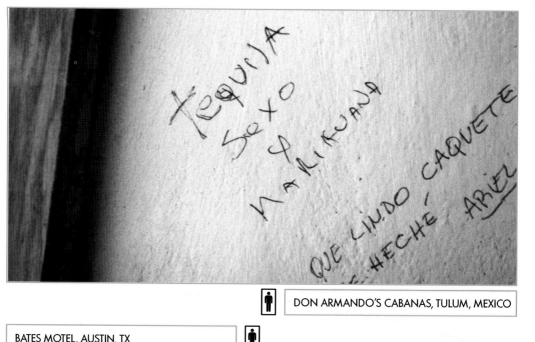

 DON ARMANDO'S CABANAS, TULUM, MEXICO

BATES MOTEL, AUSTIN, TX

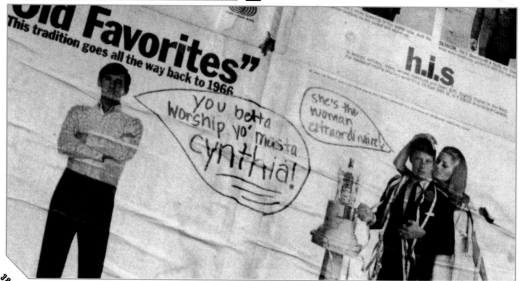

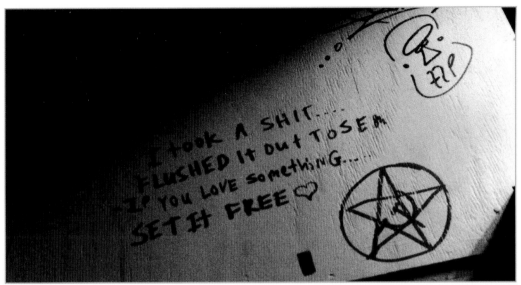

 BATES MOTEL, AUSTIN, TX

USP (HS BUILDING), SAO PAULO, BRASIL

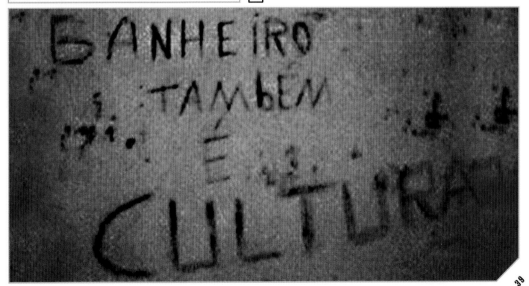

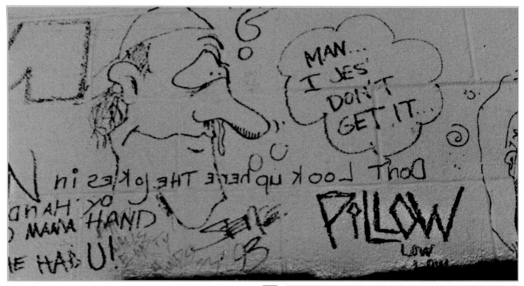

 EMO'S, HOUSTON, TX

CRAB SHACK, PANAMA CITY BEACH, FL

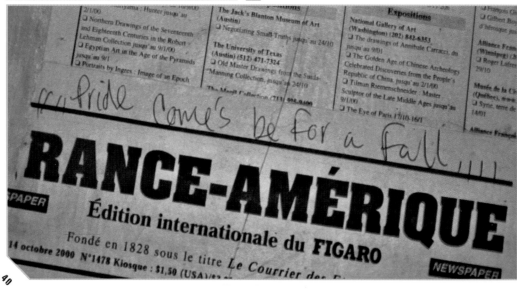

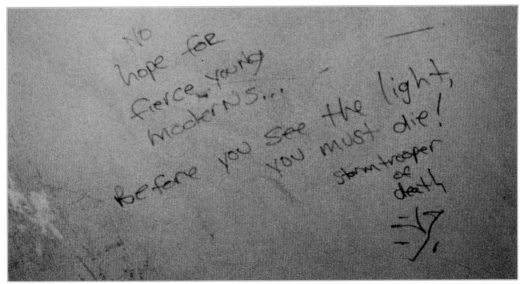

No hope for fierce young moderns... before you see the light, you must die! stormtrooper of death

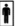
POWELL'S CITY OF BOOKS, PORTLAND, OR

TOI RESTAURANT, HOLLYWOOD, CA

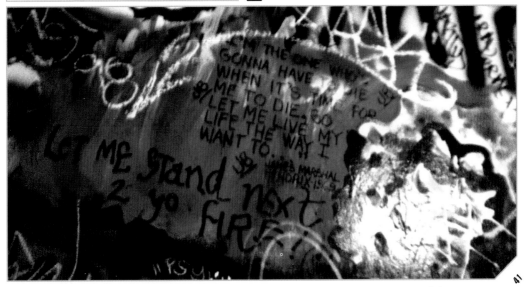

Let me stand 2 yo next FIRE!!!

I'm the one who's gonna have to die when it's time for me to die, so let me live my life the way I want to.

 MARS BAR, NEW YORK CITY, NY

MARS BAR, NEW YORK CITY, NY

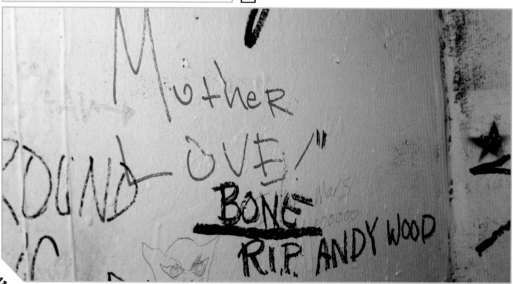

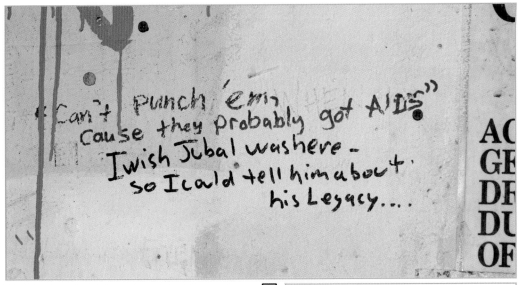

"Can't punch 'em, cause they probably got AIDS" I wish Jubal was here — so I cald tell him about his Legacy....

 MARS BAR, NEW YORK CITY, NY

LIL JOYS, ECHO PARK, CA

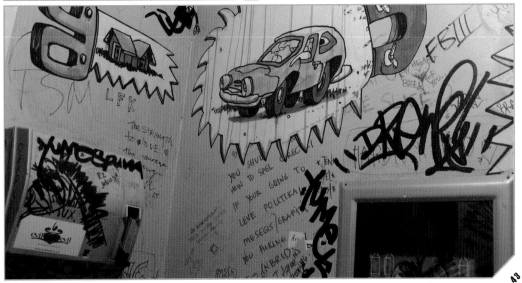

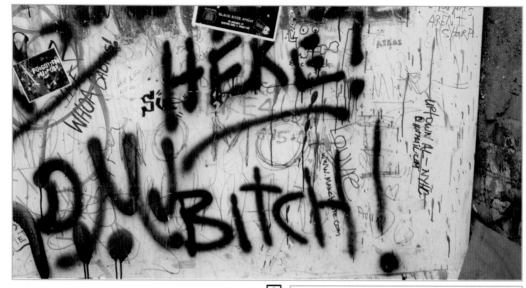

 CBGB & OMFUG, NEW YORK CITY, NY

CBGB & OMFUG, NEW YORK CITY, NY

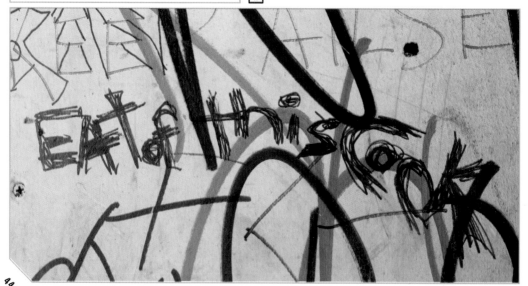

44

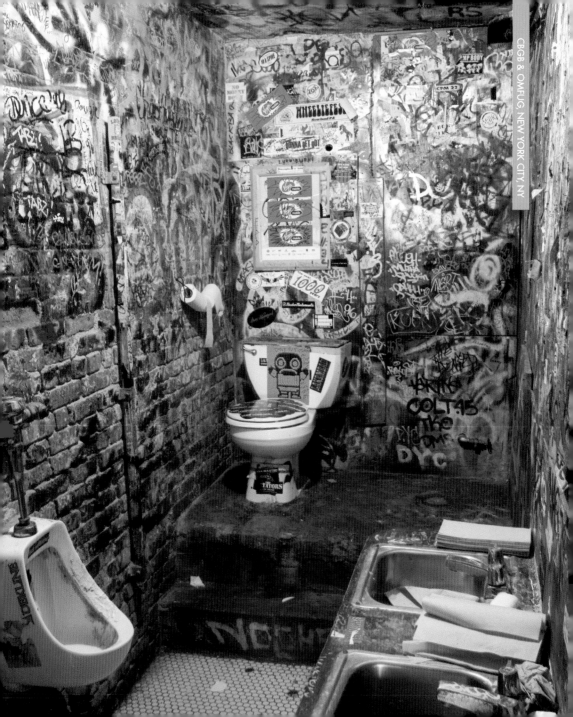

 LOLA'S BAR, HOUSTON, TX

LOLA'S BAR, HOUSTON, TX

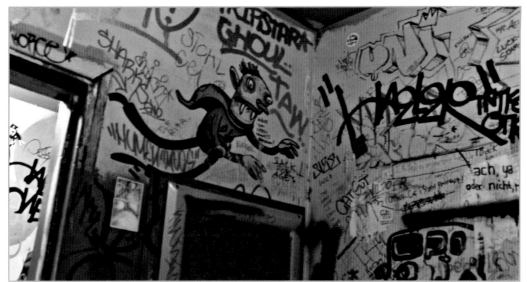

 LIL JOYS, ECHO PARK, CA

SID'S, NEWPORT BEACH, CA

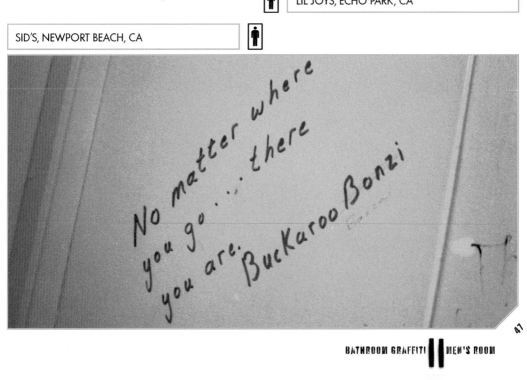

No matter where you go . . . there you are. Buckaroo Bonzi

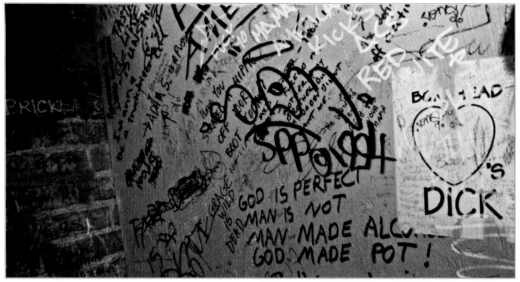

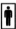 THE COMET TAVERN, SEATTLE, WA

TOI RESTAURANT, HOLLYWOOD, CA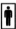

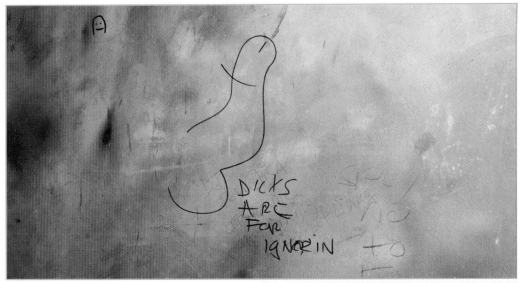

 CAMP, BROOKLYN, NY

LONG WONGS BAR, TEMPLE, AR

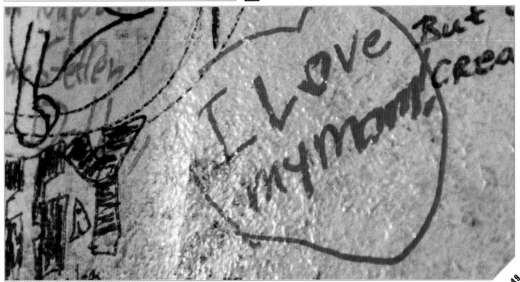

CHAPTER 2:

WOMEN'S
ROOM

Vulva Envy

It was once believed that women didn't write much graffiti in restrooms. Renata Plaza Teixeira in her Master's thesis "Musa Latrinalis: Sexual differences in restroom graffiti," and later with her appropriately titled PhD thesis "Under the Protection of Venus Cloacina: Sexual and intercultural differences in restroom graffiti," which examined bathroom graffiti in five countries, Teixeira found that women and men write proportionally about sex, but in general men produce more inscriptions on restroom doors and walls. The amount of graffiti in women's restrooms might have leaned towards the romantic in previous years, but has since equaled or outdone what you find in men's rooms.

"I'll believe in Post Feminism when there's a Post Patriarchy." (Page 58) I read that on a women's restroom wall. It says a lot about where we're at with our cultural metaphysics, the battle of the sexes, Venus and Mars, the pink sugar or blue sugar packet. Women today are writing and carving their deities into restroom walls and the masculine consciousness, projecting thoughts so men wake up and smell the decay of full spectrum patriarchal conquest.

It's time to rewire our imagination and consider a different way of organizing our reality, according to this latrinalist from Charleston, South Carolina: "There's a rip in the fabric of reality." (Page 56) Women's graffiti is blunt and to the point. It's been a

long and hard road from Mary Magdalene to Lecretia Mott, from sexism to racism; today, the Guerilla Girls give young women super power potential, and we need all of the super powers we can get. The women's bathrooms at universities, bars and coffeehouses are tattooed with antiphonal responses and images that speak to many aspects of the human condition. These latrinalists are not worried about repackaging themselves, or getting closer to god through fashion tips, or liposculpting or rejuvenating their body parts; they're more into augmenting their spirit than their breasts. Just look at this comment from CalArts Institute in Valencia, California: "Your best friend in life is not the mirror, step away." (Page 58) Or how about this one from Las Vegas: "Women of the world UNITE! Bimbos of the world Stay Home!" (Page 61) Both of these are calls to action that reflect division within the gender, but at the same time express the conscious attitude necessary to bring about a change. The thoughts and sentiments portrayed by female latrinalists transcend the cultural ambiguity that permeates the social construct today. As society applies cultural constraints to freedom,

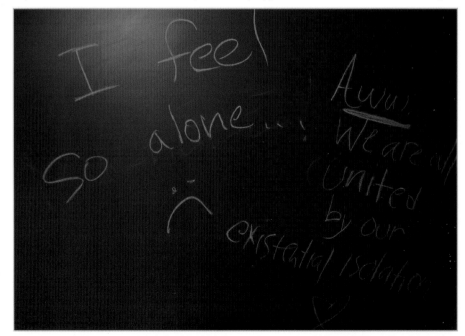

and the smell of censorship wafts through the air like a summer barbeque (or a public restroom in need of a cleaning), the women of the future world are gathering their thoughts on bathroom walls, not to incite riots but to incite the spirits of the collectively oppressed. Female latrinalists don't fit between marketing strategies, though I'm sure some raise families while others raise awareness. As one latrinalist from Austin, Texas put it: "Support your local Anarchist Mom, I'm Raising a Revolution." (Page 114)

The walls are not all hubris and dystopian angst. For instance, while shooting some images at a bar in Charleston, SC in January 2006, I approached a woman named Kathy. Well dressed and well groomed, I thought her as unlikely a candidate for graffiti as there could be. Kathy had just walked out of the women's restroom when I asked her if there were any pieces of graffiti inside; I waited for the inevitable brush off. Through an amazed, perforated smile, she asked, "Why?" I explained the project. She told me that she never paid much attention to bathroom graffiti, though she had just read something in the stall that inspired her to respond.

I asked, "What made you do it? What moved you?" She took me inside the restroom where she showed me a frowning smiley face icon and the original message: "I feel so alone..." Her written response: "Aww...We are all united by our existential isolation." Jedi mysticism, indeed. While taking a few more pictures of it she told me she felt a need to answer the woman's plea and that we all feel isolated at times, and she hopes that the anonymous author would return to see it sometime.

"Hope is our weapon," (Page 121) I said. She gave me a quizzical look and I explained that it was another bathroom adage culled from my travels.

Kathy confirmed what I had always believed to be true: we all possess the desire to help one another. And maybe she wrote her response with that in mind, with compassion and understanding.

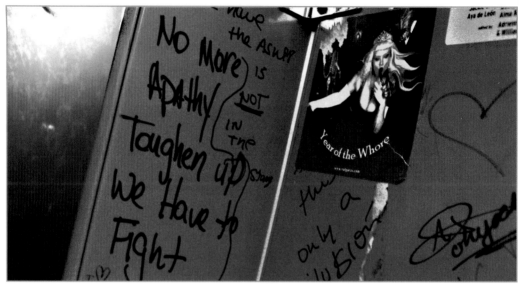

 BOWERY POETRY CLUB, NEW YORK CITY, NY

BATES MOTEL, AUSTIN, TX

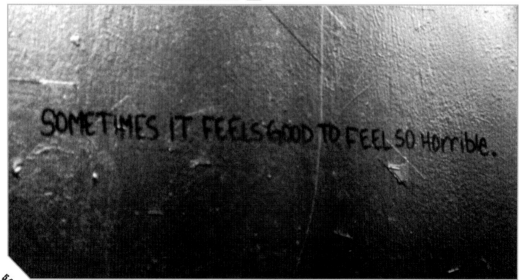

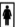 MOLLY'S CASINA, NEW ORLEANS, LA

LA GARE, EDMONTON, ALBERTA, CANADA

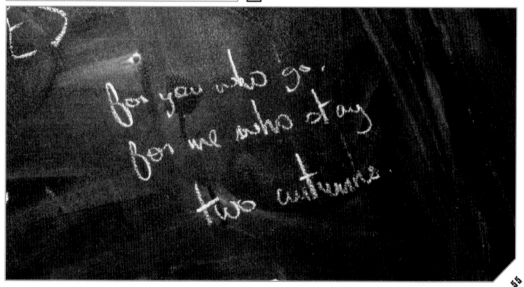

for you who go,
for me who stay
two autumns.

 UPPER DECK TAVERN, CHARLESTON, SC

UPPER DECK TAVERN, CHARLESTON, SC

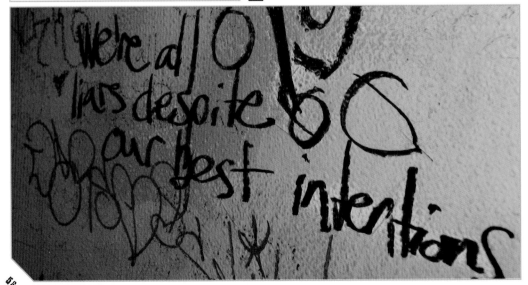

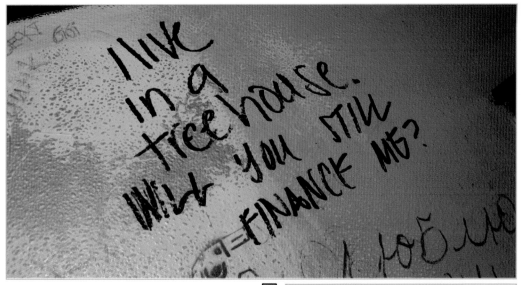

 UPPER DECK TAVERN, CHARLESTON, SC

UPPER DECK TAVERN, CHARLESTON, SC

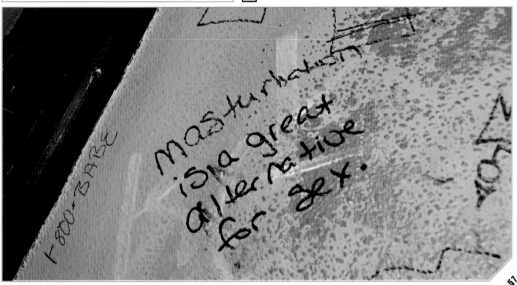

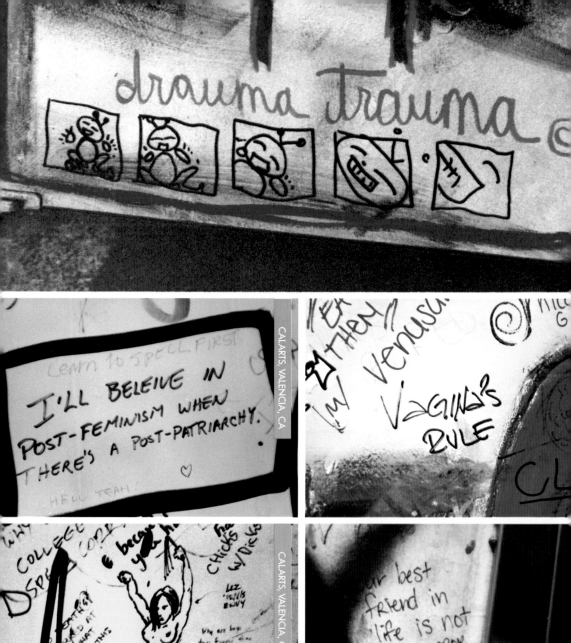

 THE DARK ROOM, NEW YORK CITY, NY

BARCADE, BROOKLYN, NY

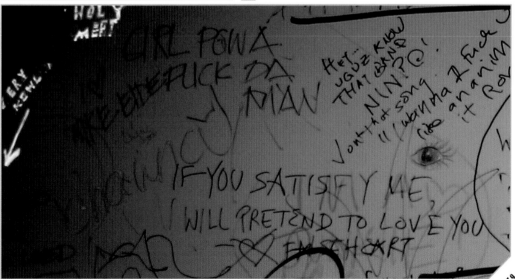

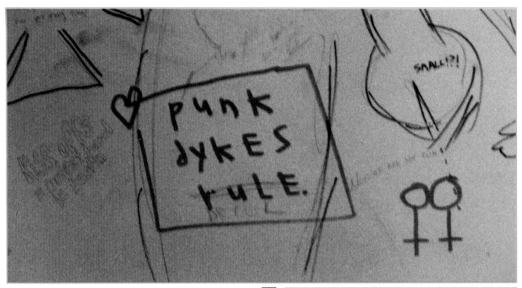

 BATES MOTEL, AUSTIN, TX

EMO'S, HOUSTON, TX

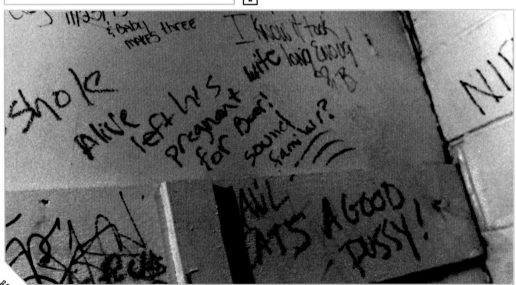

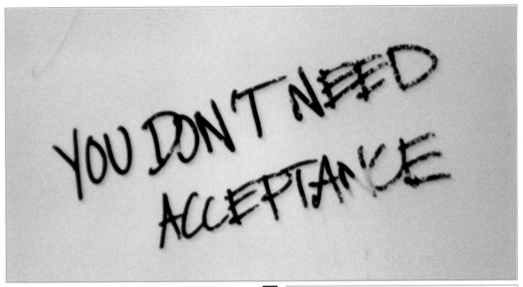

 RAINBOW ROOM, WEST HOLLYWOOD, CA

CAFÉ ESPRESSO ROMA, LAS VEGAS, NV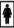

Women of the world
UNITE !

(Bimbos of the world
Stay Home !)

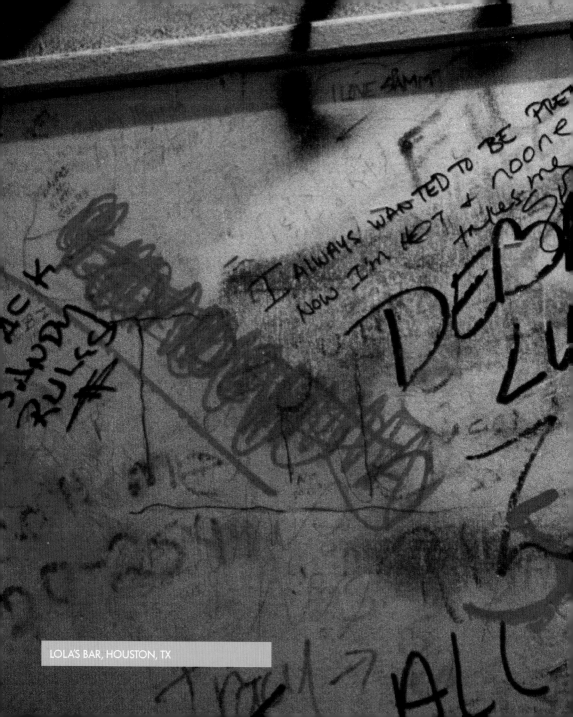

LOLA'S BAR, HOUSTON, TX

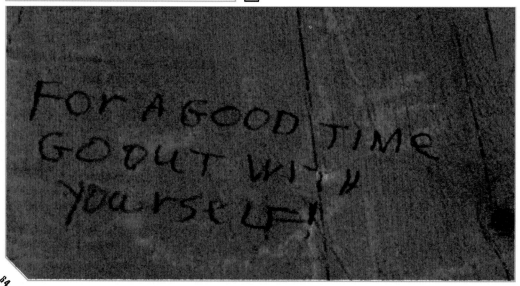

if you were me
a d were you;
would you treat yourself
so badly. ↑
 WORSE

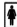 THE SUN, SALT LAKE CITY, UT

THE PONDEROSA, TIJERAS, NM

FOR A GOOD TIME
GO OUT WITH
YOURSELF!

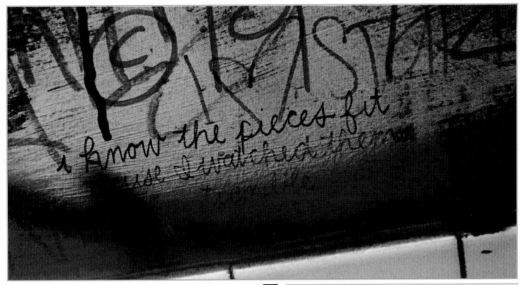

 CALARTS, VALENCIA, CA

AL'S BAR, LOS ANGELES, CA

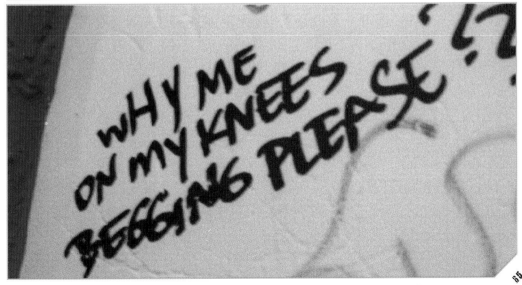

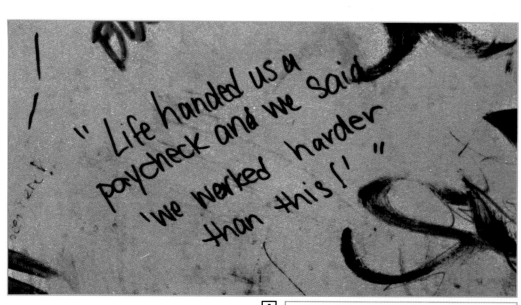

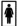
UPPER DECK TAVERN, CHARLESTON, SC

CALARTS, VALENCIA, CA

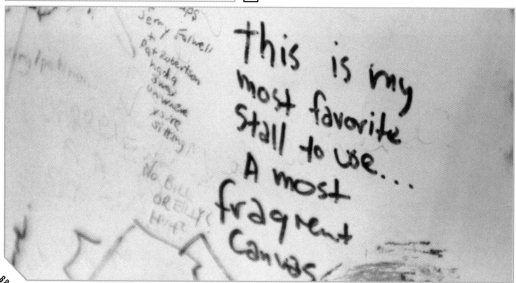

IGGY'S, NEW YORK CITY, NY

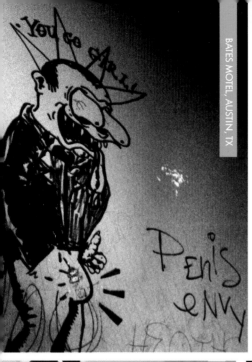

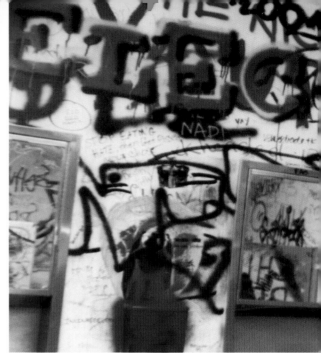

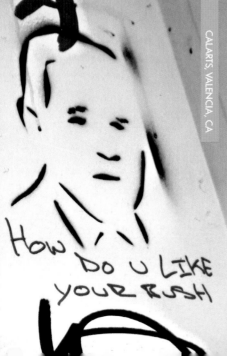

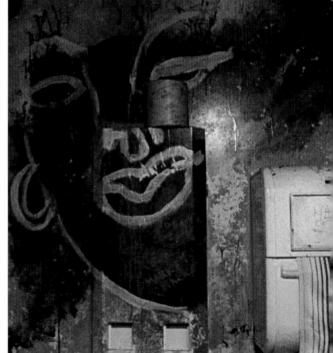

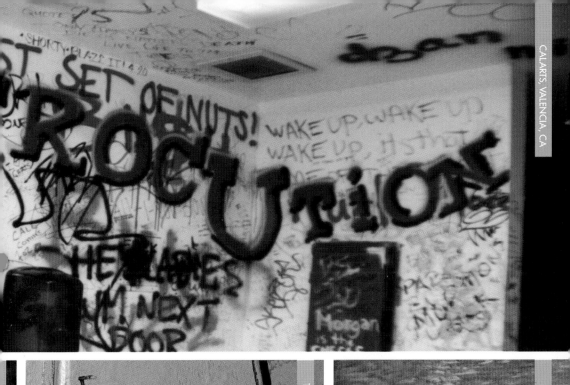

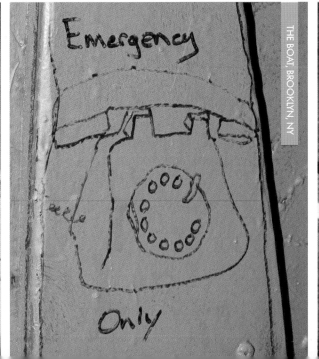

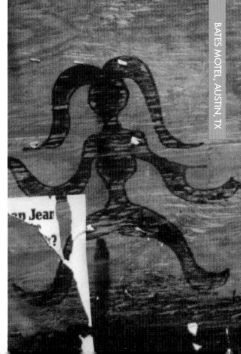

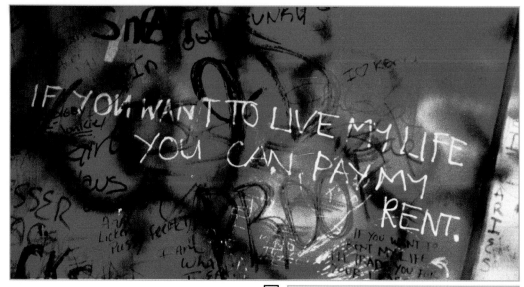

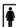 SATYRICON BAR, PORTLAND, OR

UCLA-DICKERSON ART CNTR, WESTWOOD, CA

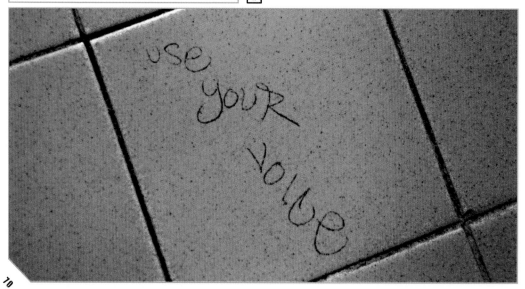

 LOLA'S BAR, HOUSTON, TX

HOLE IN THE WALL, AUSTIN, TX

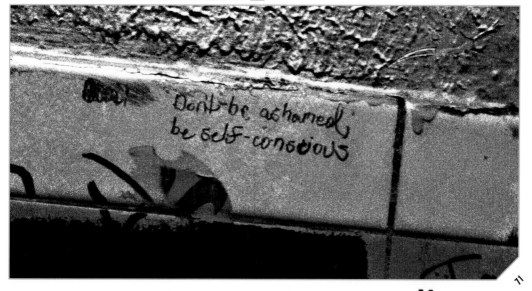

AIR-STEP

PRO CHOICE:

means — Freedom of Religion
Freedom of Choice
Pursuit of Happiness . . .

and SWALLOWING CUM

THERE IS NO MAN

THATS GONNA TEL

WHAT TO WITH MY BOD

DASHBOARD MARY

LOLA'S BAR, HOUSTON, TX

CHAPTER 3:
UNI-SEX

Escaping Identity

Unisex restrooms tend to have a higher concentration of graffiti due to the amount of foot traffic. When you walk into the unisex bathroom your identity is left at the door since most unisex bathrooms don't have urinals. The duality causes wonder. Who sat down or stood here before you? You are no longer Bobbi or Bobby, or an omnivore or a carnivore, an innie or an outtie, a conservative or liberal, a Christian or Muslim. You're removed from the circus mirror of society. It's the memory of the wall that reminds us that unisex bathrooms blur identity, it's the bathroom graffiti's own super-collider, where words and syllables crash into one another. The androgynous environ allows the latrinalist a space where thoughts and images can intermingle and not be bound by society's self-imposed hierarchy of needs.

In May 2006, I went to a venue called the "il corral," in Los Angeles, an experimental music lab, studio and performance space. I met Christie (polychrome), an artist/musician, and her partner Stane. In this space, they explore and develop music called "noise music." Because the lab shares the same space as Christie's living quarters you can imagine the graffiti, sticker and flyer activity her bathroom gets, it's definitely a unique environment.

"I have a long and endearing relationship with my bathroom," Christie says. She tends to it as if it were a garden; she regularly prunes it, weeding out the negative comments and preserving the words and images she holds dear. "As an underground medium of self-expression it's one of the most psychically charged environments," she says. As a response to a show at il corral, someone wrote on the bathroom wall: "Noise is Imagination without Skill." This prompted the response: "Imagination is a Skill," which moved Christie to write: "Imagination is Total Freedom."

Christie enjoys the little characters that people draw on the walls, left behind like mementos in a scrap book. She says, "However art might manifest it's fundamentally human to make art, or sound art. Human beings have an innate need to create." She loves the idea that she can cultivate the dialogue in her private, public space and allow an individual to affect another through an expression, thought or poem. The words and images crawl across the wall intertwined with the spirit of this Dadaesque environ. "Art doesn't have any purpose other than itself," Christie suggests, "and it exists outside of society aspiring to be something that can truly mirror it." Spoken with all the freedom of an artistic warrior. As I left the il corral I considered myself fortunate to have bumped into a like-minded soul, I know I will return later to see how Christie's graffiti garden has grown.

Bathroom graffiti's stories and cultural artifacts might leave a trail for future latrinalists to follow, in the hope that the path will lead to a better understanding of bathroom graffiti and of one another. That somehow these temporary moments we share give one that unquantifiable meaning, and that if we forget, the wall will always remember.

With Sharpie in hand, anonymous latrinalists validate their existences, meted out with every stroke of the marker. But it's the premeditated thought, the planning that goes into a poem or a drawing that shows the authors' will to claim experiences as their own, instead of buying into manufactured ones. The bathroom culture lives in the idea that it really doesn't matter who you are or what you are. The latrinalists' anonymity may only be preceded by the desire for authenticity.

As a form of communication it's not beyond human comprehension that these moments somehow foment a sense of freedom, the inspiration to express their selves without the

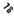

baggage their identity requires. Sure there are some tell-tale signs as to the gender, but for the most part you don't know who wrote the pithy comment or who drew the whacky caricature. You only know they're part of your extended family or at least the bi-pedal cousin no one talks about. And that might be the beauty of it, the thoughts and images expressed are more important than who wrote it.

What determines identity? Family? Your favorite beer? All the choices we make might influence the sum of identity, but it is fluid and ever evolving and unisex bathrooms perfectly reflect that. Though identity might be reflected in what one chooses to express in what they write or draw. Some latrinalist hold themselves accountable for what thoughts they might express in how they project their experience of the world around them. And of course, tucked in between the dark corner and the toilet paper dispenser, are thoughts of meaningless drivel which is not to be discounted. It's through this lens, that the culture of bathroom graffiti enjoys a diversity of perspectives that we all appreciate.

Bathroom graffiti, with its collective tongue-in-cheek, raises questions of accountability and the ridiculously sublime. Like this little nugget from Sofie's Bar in New York's East Village: "King Kong died for your Sins." (Page 78) Reality has nothing to do with this mind grenade, but it has everything to do with religion's idea of displaced accountability. Will humanity be awakened in time to accept responsibility? Can we face the reality that our bio system is in the first stages of collapse or is it all lost in the mind-numbing rush of acceptance, the inevitable ecocide? There is uneasiness in knowing that truth may come in the form of mother nature's own self-regulating hazmat team. Bathroom graffiti cross-pollinates ideas to address stories and myths that condition human behavior to make for a more memorable tale.

Latrinalists also show some concern for cultural conformity like this anti-matrix sound byte from The Smell, a speak easy music and art gallery in Los Angeles; it was in the form of a "Hello My Name Is" sticker: "Hello My Name is 1984," (Page 79) referring to the George Orwell title. It may be that this latrinalist is signaling that the individual is in its last death throes, as we all meld together in one huge corporate buy-out, wearing our corporate, state-sponsored uniforms.

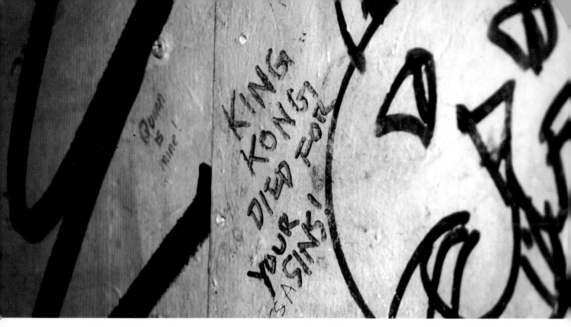

The unisex bathroom as a medium engages the space between men and women, between laughter and pain and what it means to be human. With the underlying message being that we use our muse before our muse goes mute. As humanity struggles to find meaning in its existence, our reality becomes more contrived and distorted; it becomes the object of rebellion, the struggle between truth and illusion.

So, where does it leave us? Somewhere between a Walmart January White Sale and a box car full of like-minded individuals. Can we escape who we are or what we believe ourselves to be? Still I can't help but think the restroom sages might have it right, in losing our identity we might discover who we are.

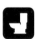

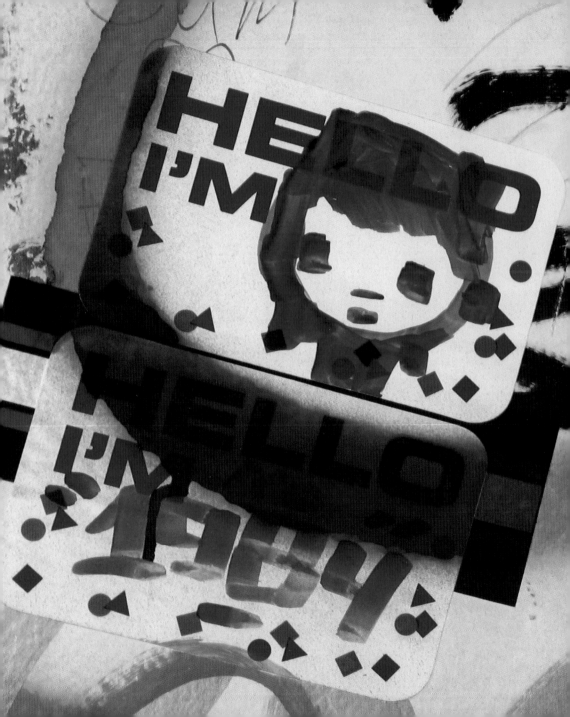

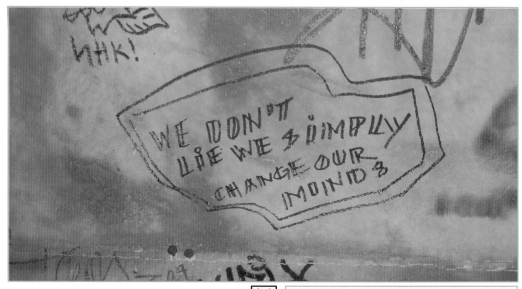

 VOL DE NUIT, NEW YORK CITY, NY

LAGARE, EDMONTON, ALBERTA, CANADA

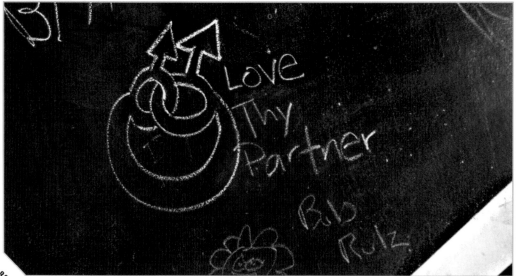

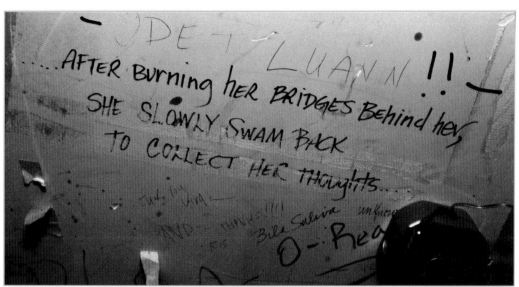

...AFTER Burning her BRIDGES Behind her, SHE SLOWLY SWAM BACK TO COLLECT HER THOUGHTS...

 THE SUN, SALT LAKE CITY, UT

IL CORRAL, LOS ANGELES, CA

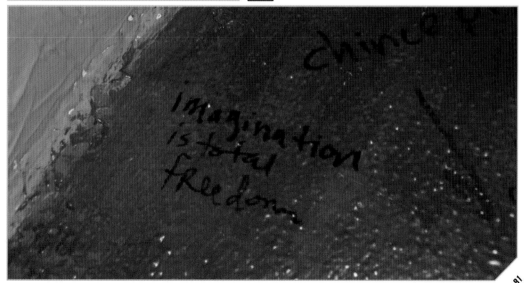

imagination is total freedom

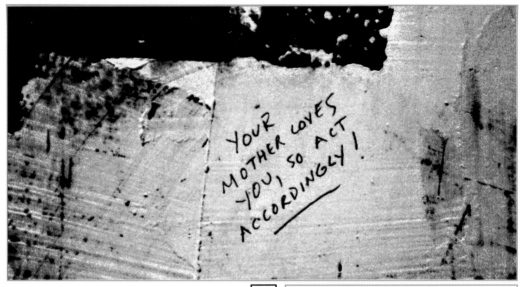

 MCGOVERN'S, NEW YORK CITY, NY

WELCOME TO THE JOHNSONS, NYC, NY

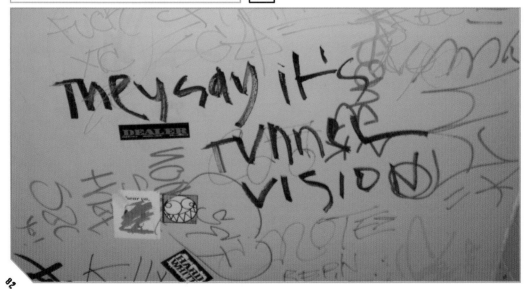

If women
are so independent,
why do they go to
the ladies room
in pairs?

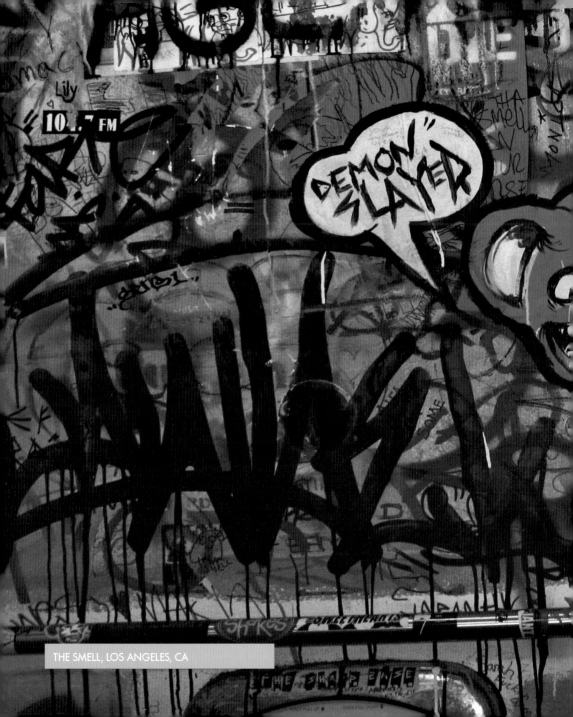

THE SMELL, LOS ANGELES, CA

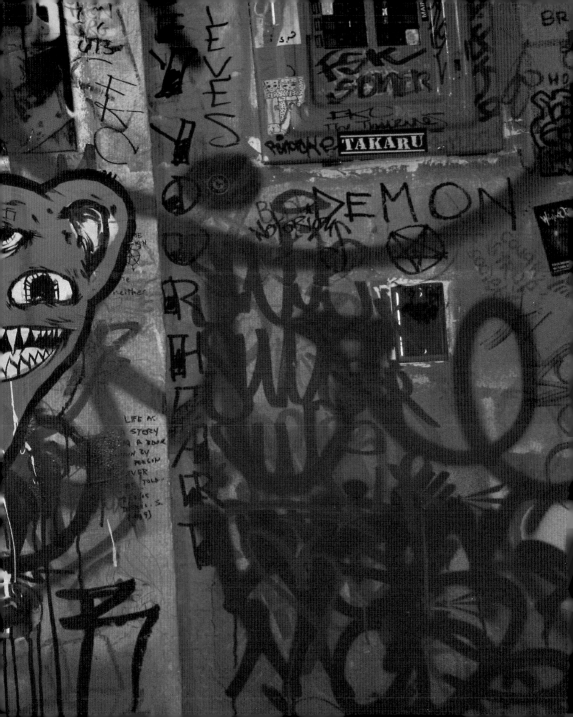

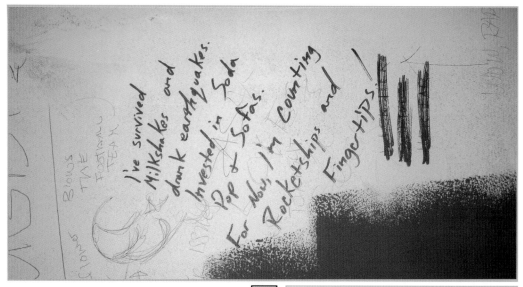

I've survived Milkshakes and drank earthquakes. Invested in Soda Pop & Sofas. For Now, I'm Counting Rocketships and Fingertips.

 GOWANUS YACHT CLUB, BROOKLYN, NY

GOWANUS YACHT CLUB, BROOKLYN, NY

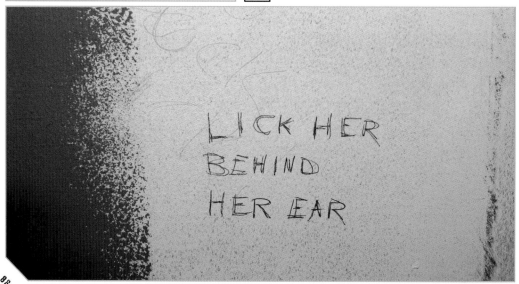

LICK HER BEHIND HER EAR

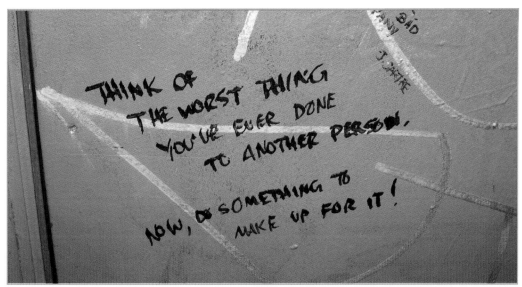

 THE BOAT, BROOKLYN, NY

THE BOAT, BROOKLYN, NY

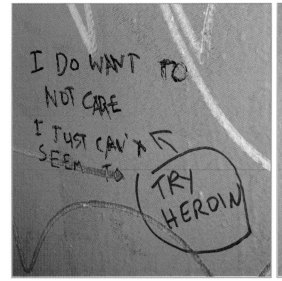

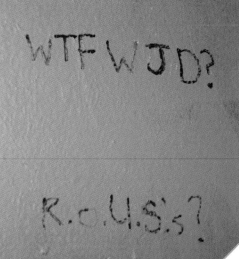

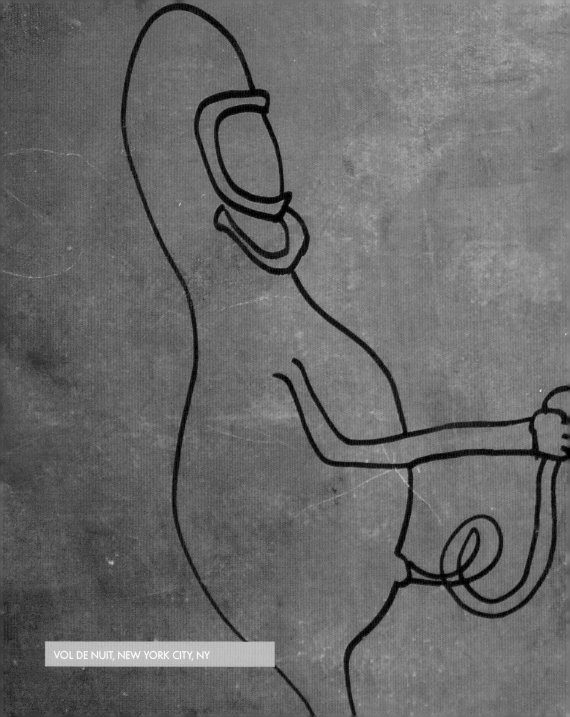

VOL DE NUIT, NEW YORK CITY, NY

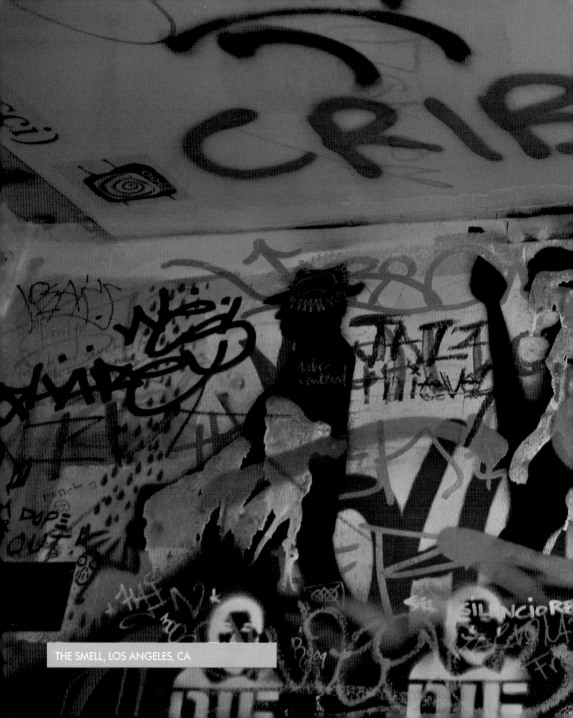

THE SMELL, LOS ANGELES, CA

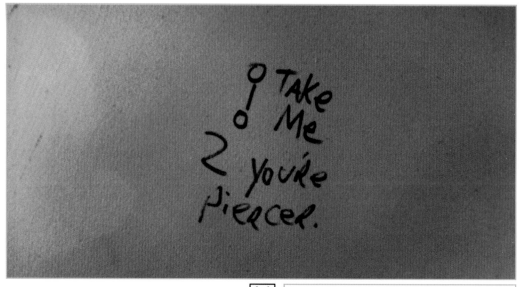

 ARRON'S, AUSTIN, TX

MAX FISH, NEW YORK CITY, NY

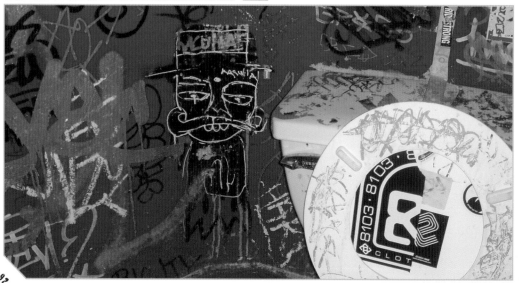

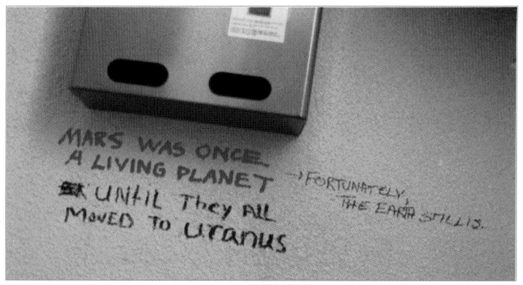

MARS WAS ONCE A LIVING PLANET UNTIL They ALL MoveD To uranus →FORTUNATELY, THE EARTH STILL IS.

 MONTAGE RESTAURANT, PORTLAND, OR

ONYX CAFÉ, LOS ANGELES, CA

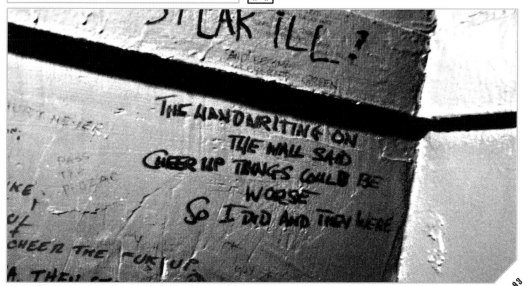

SPEAK ILL?

THE HANDWRITING ON THE WALL SAID CHEER UP THINGS COULD BE WORSE So I DID AND THEY WERE

e
wareness
soul.
A measure
of
Being
Nowhere
From
No
wher
ife?
tion

Fuck BAD Relationships
cut them out of your life

v

Limp

Anti-Limp Dick Fr
(she will hate you

eace

mc.net

Mother
rosa

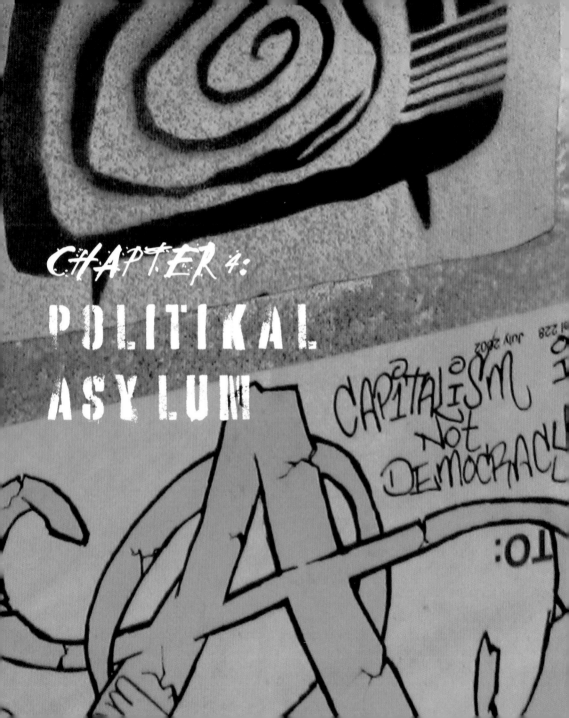

CHAPTER 4:

POLITIKAL
ASYLUM

CAPITALISM
NOT
DEMOCRACY

Toilet Capital

From civil liberties to national ID cards, latrinalists touch on issues from the right and left wings, from environmentalism to gun control. All bathroom graffiti is politically toned, some examples more overt than others. Like this voice of dissent scrawled on a wall at Sid's Bar in Newport Beach, California: "Government is not reason, It is not eloquence, It is force, and force like fire, is a dangerous servant and a fearful master." (Page 98) That's from George Washington.

Could bathroom graffiti be a more patriotic gesture than it is thought to be? After all what's freedom without expression?

Perhaps political bathroom graffiti acts as a release valve; it may have restorative qualities in that it helps alleviate societal stress. The Romans knew this, it's why the coliseum packed every weekend, it seems diversionary entertainment has always guaranteed a sedate populous. The coliseum of today pits one culture against another, the Super Bowl of apocalyptic soufflés, Survivor's Armageddon Cook Off.

Bathroom walls rage in protest, sounding rallying cries for the latrinalists that take up the pen, like this one from Bozeman, Montana: "Smash the state defend Mother Earth." (Page 99) The environment is in such a state of rebellion that the cows have gone mad and flocks of birds spread the avian flu. Disease is ramping up for its own version of

full spectrum dominance as mutating bacteria begin dispatching humans from their bodies. Which reminds me of this one from Al's Bar: "Burger Kill." (Page 100) It's only fitting that a flesh-eating bacteria liberates us.

The socio-economic politics of transnational corporate states are impacting every facet of life on the planet, from soybeans to human beings, from manufactured wars to fabricated moments. As the psyche of humanity is being force-fed the politics of fear, emotional pandemics and global insecurity, the trauma based control is at such a level of saturation that if one doesn't question the method of conditioning, well they may already be conditioned beyond recognition. As the bodies are piled up at the sacrificial alter of the economic gods of consumption, ecocide might be the last thing to worry about as there may not be enough Paxcil or Luestra to go around.

Our government and the media tell us to buy, buy, buy in the name of freedom and democracy, even as our civil liberties are restricted and the mainstream media resembles advertising agencies. I'm reminded of Ben Franklin's warning to the future citizens when he stated: "Those who would sacrifice liberties in the name of security deserve neither." A man of vision, perhaps he knew at some point the wheels might fall off this grand experiment. In this on-going excavation of latrinalia, I realize there's a thin line between tyranny of the mind and the amount of toilet paper brands I have to choose from.

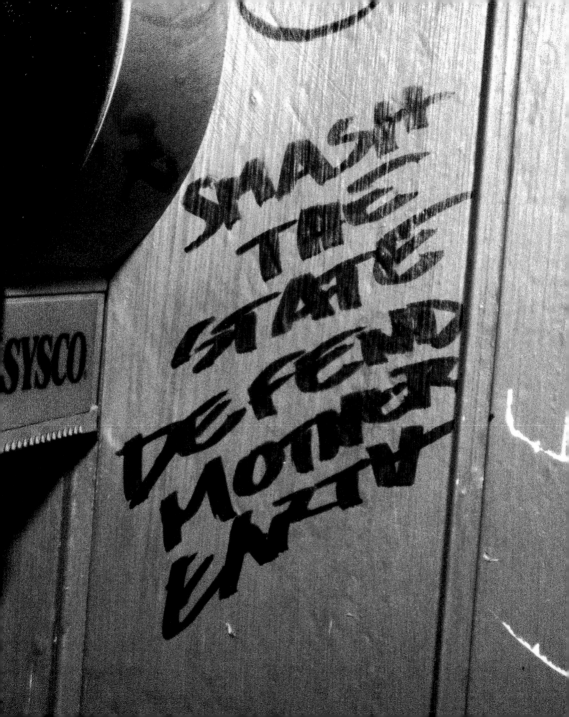

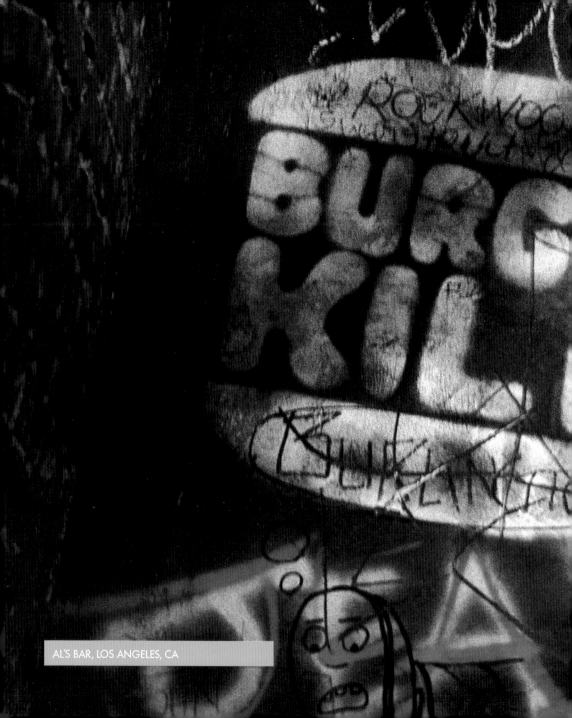

AL'S BAR, LOS ANGELES, CA

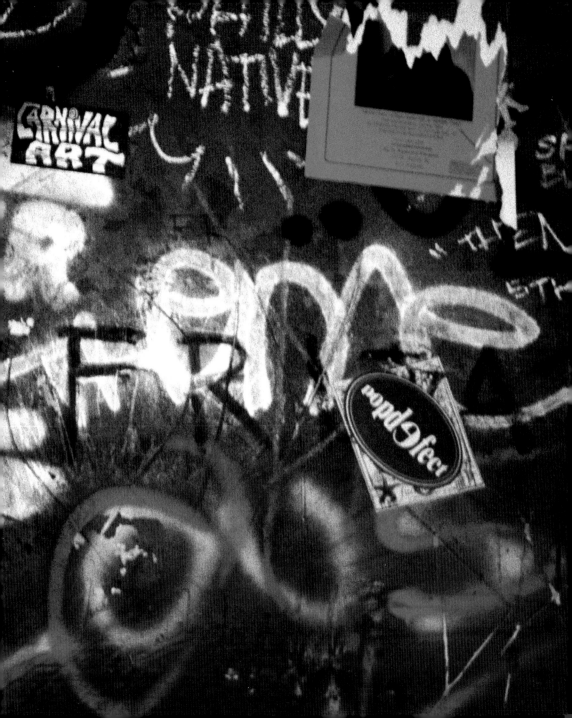

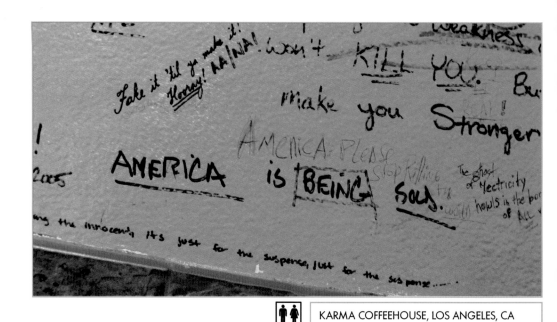

KARMA COFFEEHOUSE, LOS ANGELES, CA

CALARTS, VALENCIA, CA

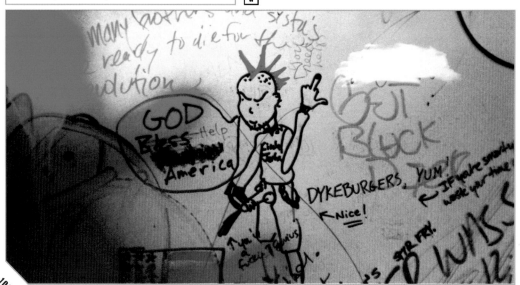

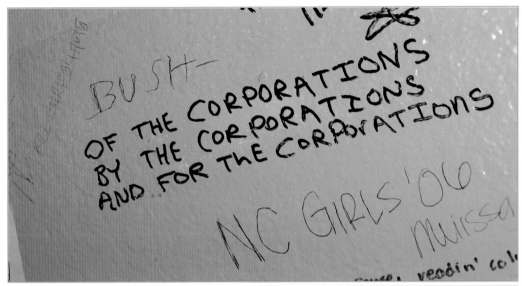

BUSH—

OF THE CORPORATIONS
BY THE CORPORATIONS
AND FOR THE CORPORATIONS

NC GIRLS '06

Mlissa

readin' col

 KARMA COFFEEHOUSE, LOS ANGELES, CA

ROYAL GROUNDS, BERKELEY, CA

Punishment leads to fear.
Fear leads to obediance.
Obediance leads to freedom.
Therefore punishment is freedom.

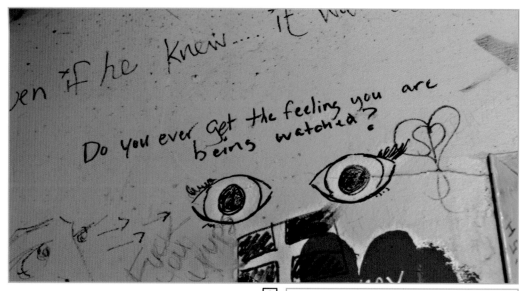

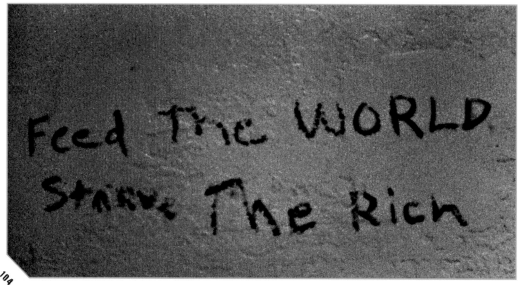

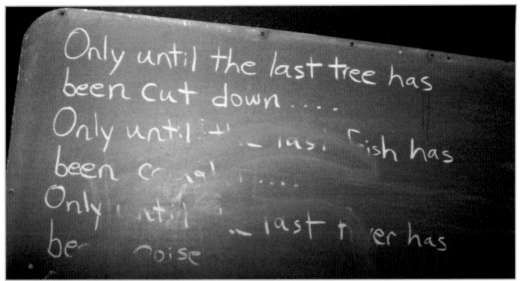

 MISTY, CALGARY, ALBERTA, CANADA

Only until the last tree has
been cut down....
Only until the last fish has
been caught....
Only until the last river has
been poise

LONG WONGS BAR, TEMPE, AR

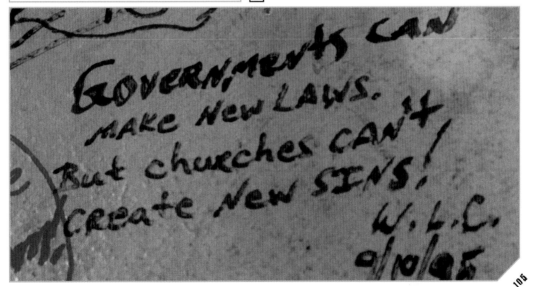

GOVERNMENTS CAN
MAKE NEW LAWS.
But churches CAN'T
CREATE NEW SINS!

W.L.C.

9/10/95

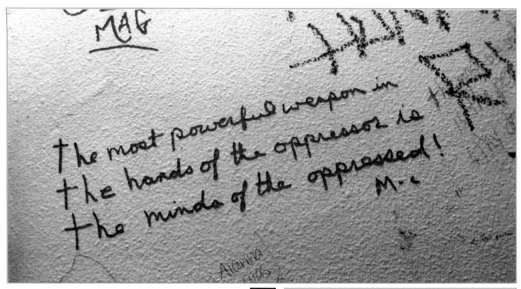

The most powerful weapon in the hands of the oppressor is the minds of the oppressed!
M.c

 ROYAL GROUNDS, BERKELEY, CA

INSOMNIA, LOS ANGELES, CA

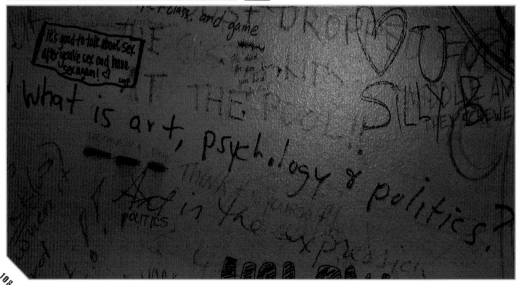

It's good to talk about sex, after you've sex and have sex again! 💋

what is art, psychology & politics?

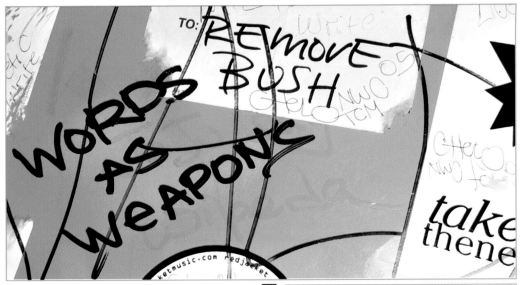

 BOWERY POETRY CLUB, NEW YORK CITY, NY

LIL JOYS, ECHO PARK, CA

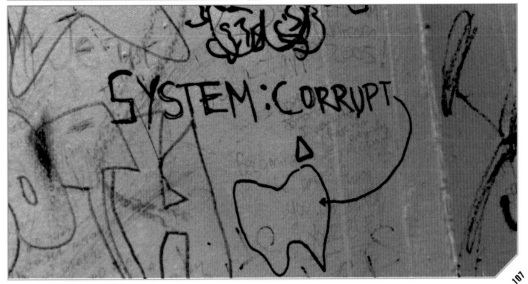

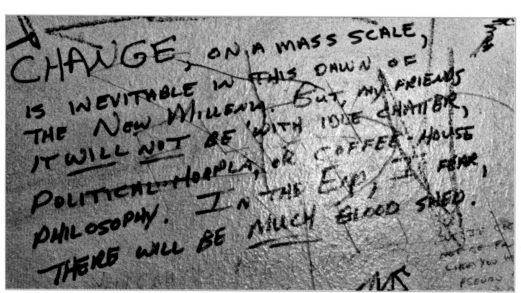

 BLUE IGUANA, HOUSTON, TX

AMBASSADOR HOTEL, LOS ANGELES, CA

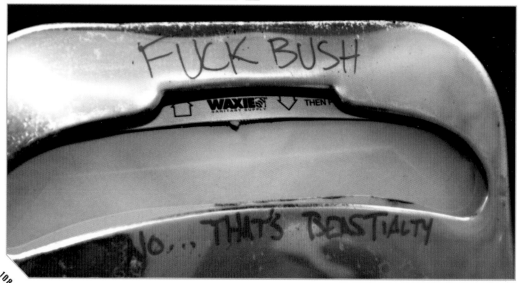

 VOL DE NUIT, NEW YORK CITY, NY

AMBASSADOR HOTEL, LOS ANGELES, CA

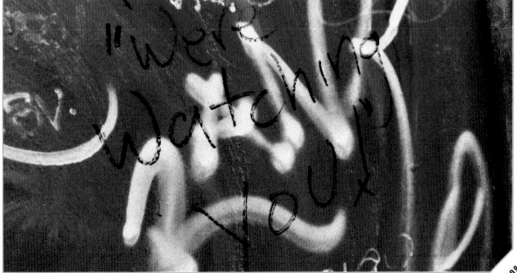

WE SHALL
SEIZE HER
GATES AT
MORNING.
WE SHALL BE
INSIDE BY
EVENING

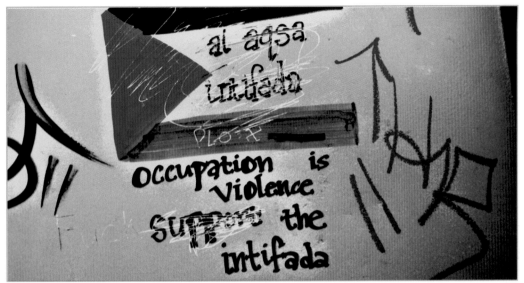

 ROYAL GROUNDS, BERKELEY, CA

INTERNATIONAL CAFÉ, SAN FRANCISCO, CA

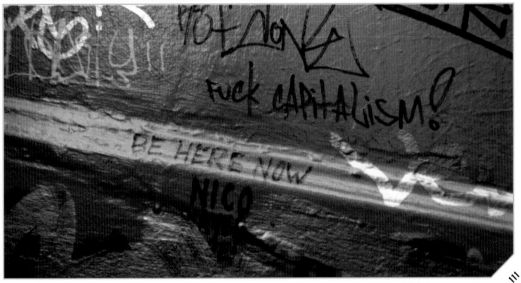

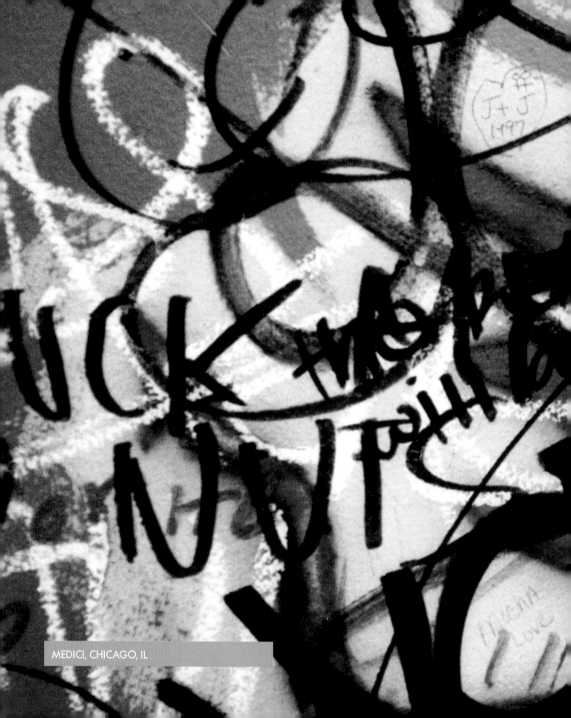

MEDICI, CHICAGO, IL

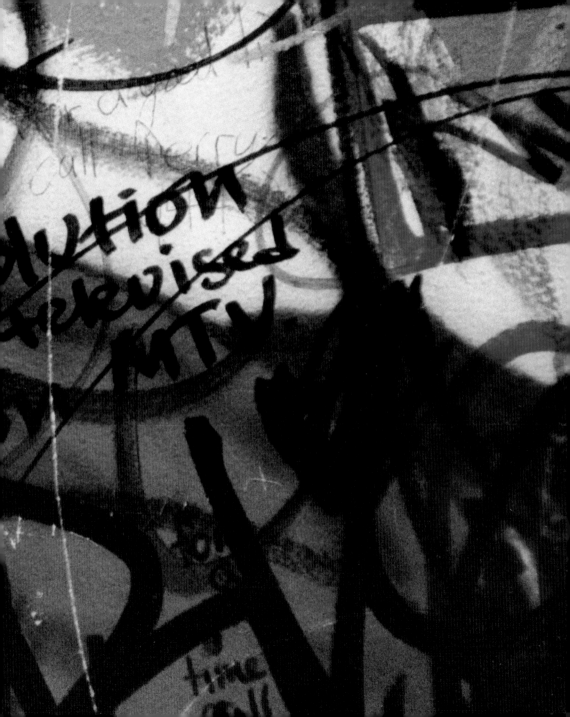

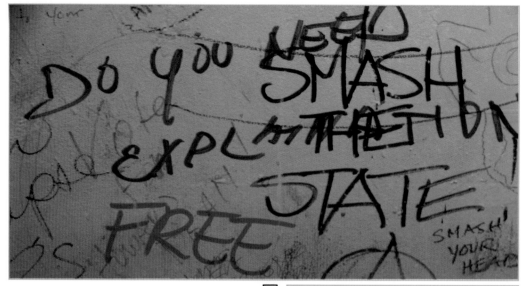

 LIL JOYS, ECHO PARK, CA

LOVEJOYS, AUSTIN, TX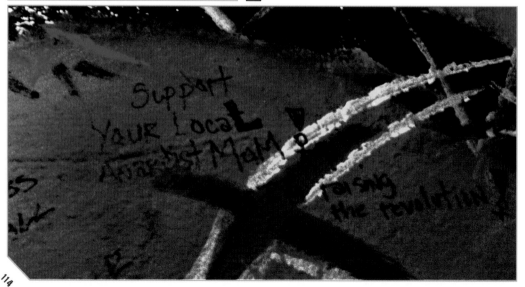

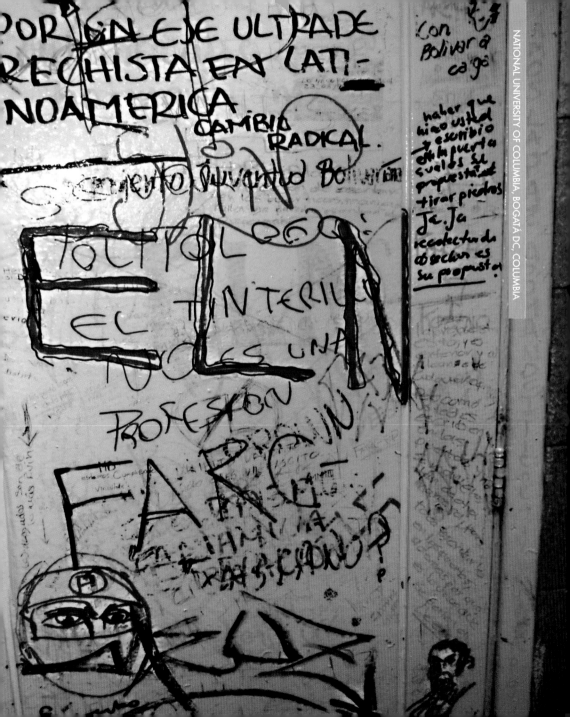

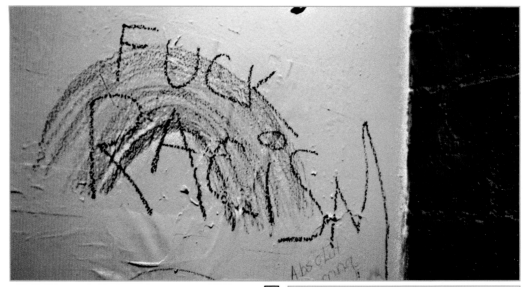

FUCK RACIST

Absolutely...

AL'S BAR, LOS ANGELES, CA

CALARTS, VALENCIA, CA

Get in TOUCH
WITH YOUR PROSTATE.
- GET IN TOUCH
WITH YOUR PRO-STATE. -

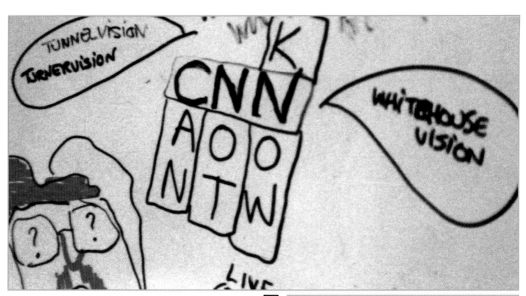

 CALARTS, VALENCIA, CA

AMBASSADOR HOTEL, LOS ANGELES, CA

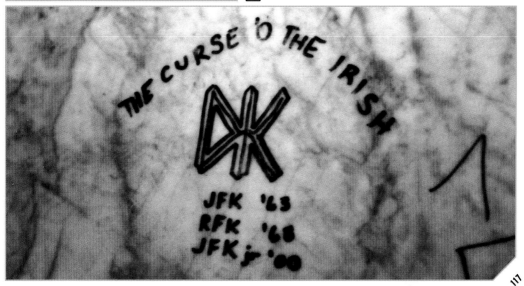

CHAPTER 5:
APOKALUPSIS
NOW

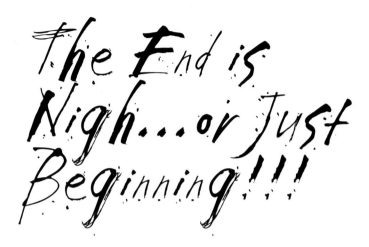

The End is Nigh...or Just Beginning!!!

"Armageddon is nearly upon us and the streets will flow with the blood of the non-believers." (Page 125) Too long for a state motto and not quite the vacation theme I was looking for, but it's somehow appropriate to the location. I saw this on a restroom wall at a bar in Charleston, South Carolina. Bathroom graffiti acknowledges all forms of belief systems, some latrinalists even suggest starting your own. It's not such a bad thought considering that quite a few traditions guarantee the world will eventually come to some kind of self-fulfilling, rapturous, gnashing of the teeth end.

We are at the crossroads of dogma, scientific tipping points and what appears to be an evolution of consciousness, I hope. But regardless of what humanity thinks, the cyclical nature of earth may soon run its course, and humanity may just be in for the ride of its collective life. From corporations to the charlatans of enlightenment, all are hoping to survive this cataclysm of uncertainty. The thing is there's only so much room in a privately funded space craft.

The interesting thing about latrinalia is its paradoxical essence: creation and destruction. These archetypical themes weave through all ancient mythologies.

Sometimes the bathroom takes on a sanctuary, zen-like silence where the words and images string together like prayer beads. These latrinalists celebrate the dynamic of ritual from the religious to the spiritualized; the bathroom graffiti illustrates how hopeful intention might influence destiny. The power of word and image conspires to reveal the thoughts and emotions of latrinalists, instruments of expression for something much greater than themselves.

The average person labors in obscurity enjoying what is believed to be the fruits of labor, or at least the fruit that they're able to reach. The latrinalists are reaching for something else, that invisible fifth element. In the landscape of the soul, spiritual nutrition sustains them. Others look for the next epiphany etched onto the conscience of humanity ever since fear and knowledge became a means of cultural control. While progress dominates the burden of human existence, most find comfort in the doubt of not knowing, because waking from slumber is too much to bear.

These latrinalists have chosen a path less traveled in the world of bathroom graffiti, of all the minutiae this planet has to offer they choose to comment on the religious and spiritual aspects of human culture. These spiritual latrinalians are disenchanted as they inherit a world that looks nothing like the promising brochure. Inspired by spiritual laxatives these latrinalists fearlessly express themselves as they pose the question: Isn't the problem inherent in the system?

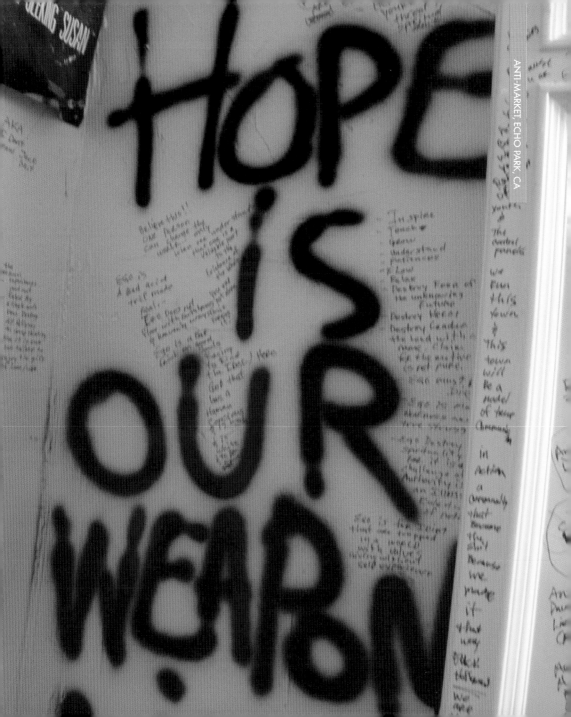

Upon my return from Charleston, a city drenched in history, folklore, apparitions and Gullah culture, I reflect on how every moment has its time and space. Bathroom graffiti elevates the common moment and its intention. As one piece of latrinalia states: "One Love, One People, One Destiny." The spirit of latrinalia may not be in the words and images but in the consciousness in which it is written. We are all one, one planet of spiritual immigrants sharing the same soul. The definition of the word "apocalypse" is to reveal what is hidden, derived from the Greek "apokalupsis" meaning revelation, literally, "a lifting of the veil." I eventually look up South Carolina's State Motto, DUM SPIRO SPERO, "While I breathe, I hope".

Hmmm...that wasn't in the brochure.

When THE LAST
TREE FALLS,
WHEN THE LAST
RIVER IS POLLUTED
& WHEN THERE IS
NOT A BREATH
OF CLEAN AIR
LEFT, PEOPLE
WILL REALIZE
YOU CAN'T
EAT MONEY

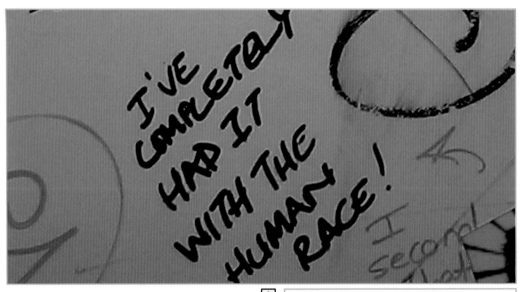

 BARCADE, BROOKLYN, NY

ONYX CAFÉ, LOS ANGELES, CA

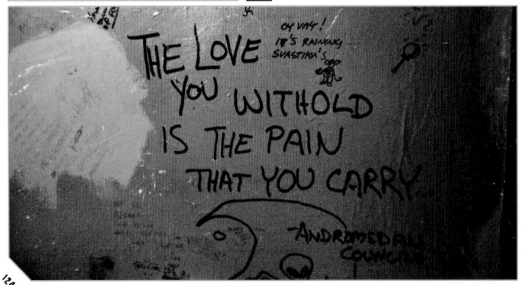

124

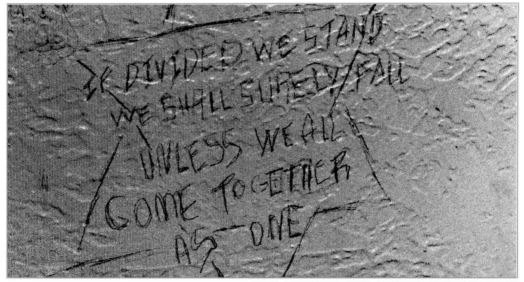

 EJ'S COFFEE & TEA CO, ALBUQUERQUE, NM

AC'S BAR & GRILL, CHARLESTON, SC

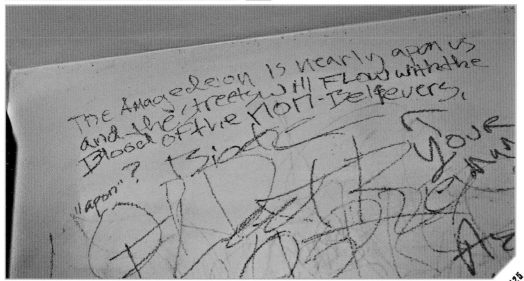

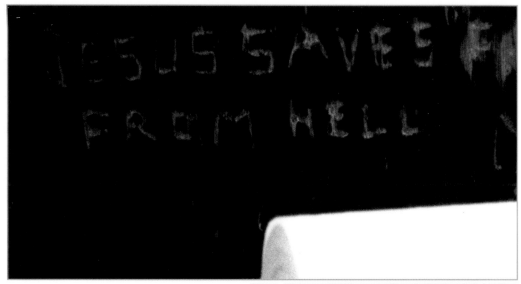

 SHELL GAS STATION, KINGMAN, AR

BORDERS BOOKS, WESTWOOD, CA

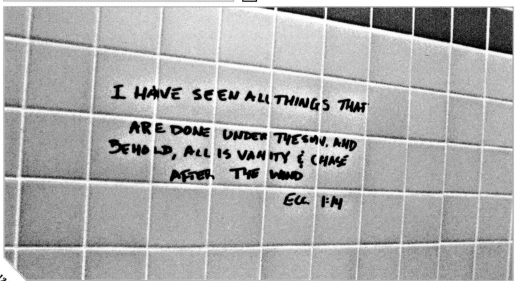

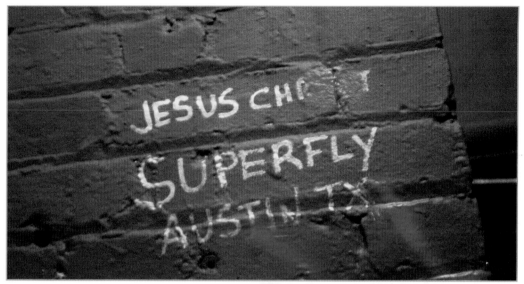

 AL'S BAR, LOS ANGELES, CA

MISTY COFFEEHOUSE, CALGARY, ALBERTA, CAN

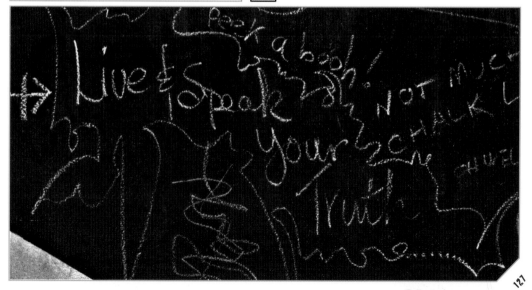

THE WORLD WOULD
BE BETTER WITH YOUR
PANTS DOWN!

E ARE NOT IN THIS
A LONE

Demand the truth
There Here Now!!!

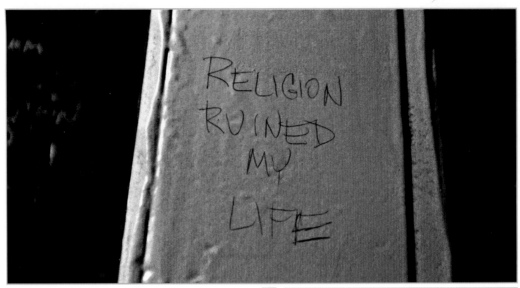

 SMOG CUTTERS, SILVER LAKE, CA

COYOTE UGLY, NEW YORK CITY, NY

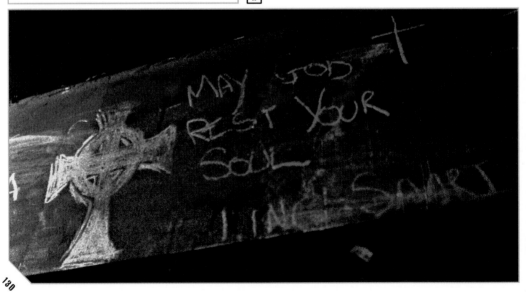

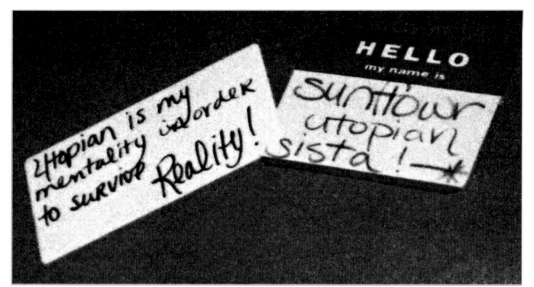

 CAFÉ FLORIAN, CHICAGO, IL

ONYX CAFÉ, LOS ANGELES, CA

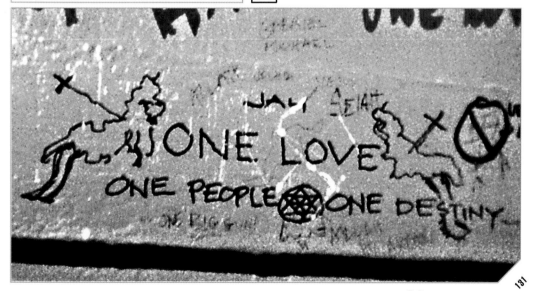

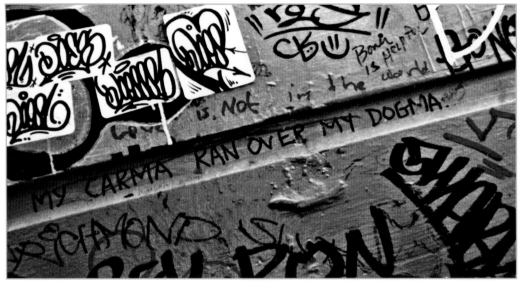

 INTERNATIONAL CAFÉ, SAN FRANCISCO, CA

HIGHLAND GROUNDS, LOS ANGELES, CA

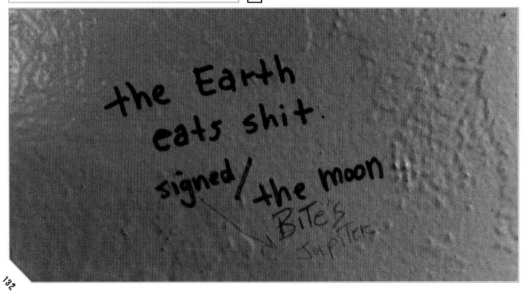

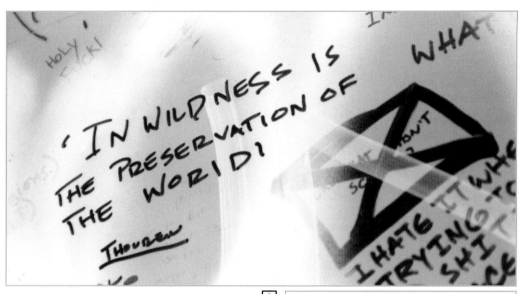

'IN WILDNESS IS THE PRESERVATION OF THE WORLD'
THOUREAU

I HATE IT WHE TRYING TO SHI

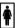 CALARTS (CORRIDOR), VALENCIA, CA

BOWERY POETRY CLUB, NEW YORK CITY, NY

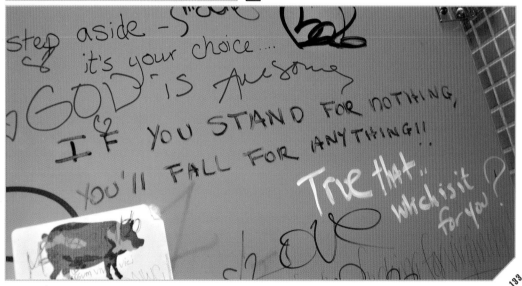

step aside – small
it's your choice....
GOD is Awesome
IF YOU STAND FOR nothing,
YOU'll FALL FOR ANYTHING!!
True that..
which is it for you?

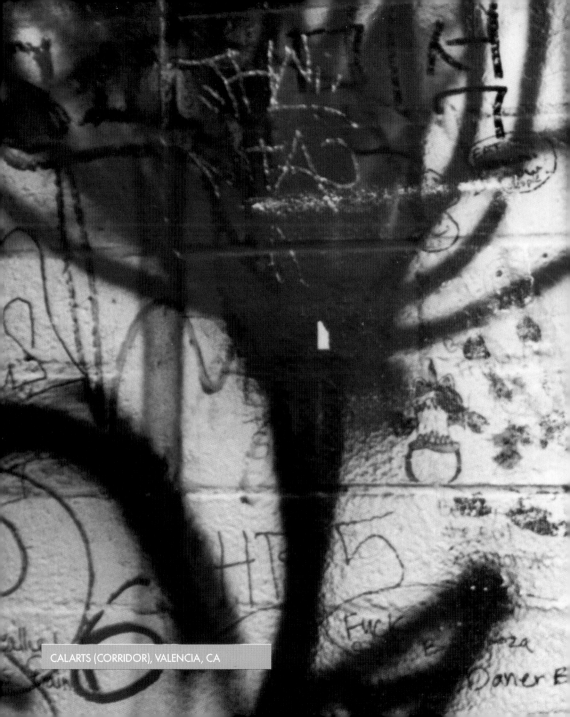

CALARTS (CORRIDOR), VALENCIA, CA

To the one true GOD ABOVE HERE is MY PRAYER NN NOT THE FIRST You've HEARD, BUT THE FIRST I WROTE.

GET MARRIED, THE EASIEST COME TO
SCRUTINY

— ELIZABETH TAYLOR

FACE THAT LAUNCHED

CHAPTER 6:
RANDOM FIRING
NEURONS

FUNNY, HAHA?
OR FUNNY, STRANGE?

Synaptic Flushings...

Culture jammers reappropriate public space, or at least alter it. Bathroom graffiti becomes a unique equalizer, a form of mass communication that's been grafted into the public consciousness. Because bathroom walls have yet to be co-opted by the counter culture trend spotters, they allow people from any and all social, economic and cultural backgrounds to have a voice. The firing neurons vary from the generational imperialism, to the raw and bizarre trickster commentary. Consider this little fragmented shard: "Fearful Angels Tread Lightly by the Awakened Masses." (Page 138) Spoken with the clarity of a court jester on a psychotropic cocktail, it's from a unisex restroom in San Francisco, which suggests that spiritual memory is attempting to retrieve what's buried in humanity's conscious. What could be embedded in humanity's mythical history, that's been blurred through time and cleansed by religion that these angels could possibly be fearful of? Awakened Masses, lets hope so. Whether bathroom graffiti stimulates conversation or nerve endings these thought forms are punctuated with moments of inspiration, sometimes whimsical but always free from mental constraints. The medium truly represents a cross-cultural dynamic of expression and free speech, which at the very least deserves a moment of attention.

The latrinalists liberate themselves through their stories and experiences as they take refuge at these porcelain confessionals. The airing of these personal truths sustains them by the act of freeing themselves not from who they are but from who they are becoming, from the idea of living up to a particular construct. This consciousness is part of the ritual as latrinalists bathe in the irony of the conditioned responses controlled by the media.

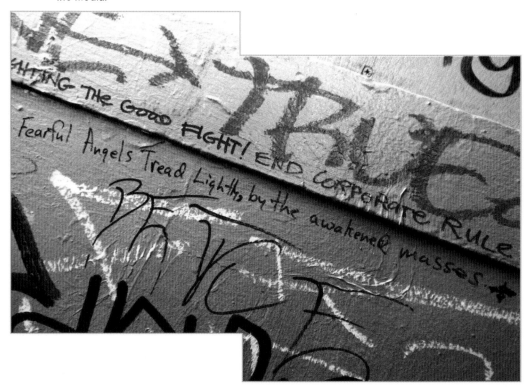

Are we becoming more the projected image, the shadows of silhouettes where the face of content is being stripped away from reality? Focusing only on the power of image, the media perpetuates form over content. I saw a car commercial pose the question, "When does a car become more than a car?", as if it could magically

become your friend. As advertisers battle for mindshare, the sweet spot of branding consciousness, latrinalists purge themselves of the synaptic slush on the bathroom walls. In our consumer-based society we breathe through our possessions that we no longer own, rather they own us. We knowingly accept media's unwritten contract that our innocence be exchanged for our ignorance. As the media industrial complex becomes the substitute for experience, it's the lie masquerading as the truth, and the lie we must believe as we become the imitation. Or as one latrinalist from Oregon stated "Reality is a figment of your imagination." (Page 140)

It's our imagination that will save us from ourselves, that will allow us to change our perception of how to look at everyday occurrences and how we see one another. As Ansel Adams once documented natural landscapes in the 1930s, the words and images of bathroom graffiti document psychological mindscapes in much the same way. This consciousness flows from its humble beginnings, in the desire of the human impulse to make a mark, these syllables and images are brought to consciousness by that divine spark of the firing neuron. These words and images that bubble to the surface are determined to be heard and seen, no matter the venue. Acknowledging their existence maybe all that matters to latrinalists, as theirs is the art of the people entertaining a captive audience that's just passing through these temporary moments, dreaming of what it means to be free.

It's on the periphery of this vision we get a glimpse of the humor, pain and carnage of bathroom graffiti, this sub-text of human experience. These latrinalists find it in themselves to operate in this realm in which they can have an affect. From scholars to the general public from doodles to grout writings, it's the place where thoughts go to die, to ask forgiveness, to inflict the comfortable, to become immortal, to be flawed or golden, to be human. Whether you have read it, written it or acknowledged bathroom graffiti most everyone at one time or another has participated. The fact that we all react to it differently is the beauty of it's never ending dialogue.

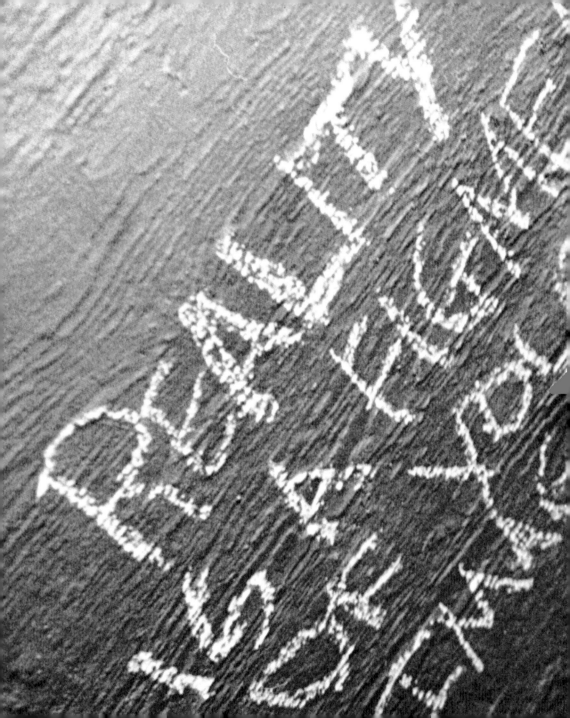

RESTSTOP, JOSEPHINE COUNTY, OR

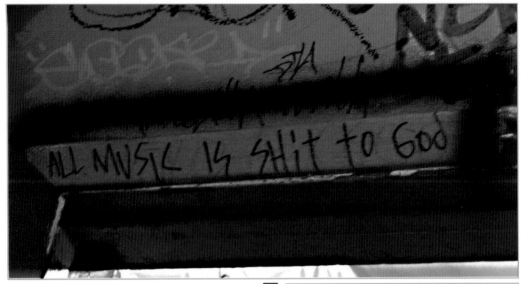

 LIL JOYS, ECHO PARK, CA

HIGHLAND GROUNDS, LOS ANGELES, CA

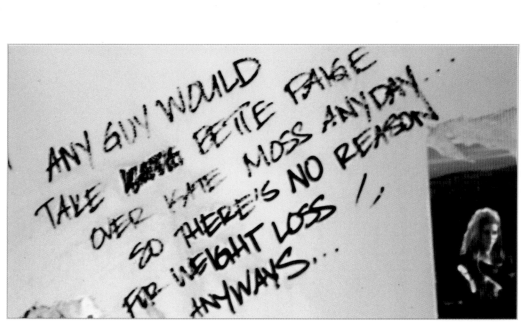

ANY GUY WOULD TAKE BETTE FANGE OVER KATE MOSS ANYDAY... SO THERE'S NO REASON FOR WEIGHT LOSS //, ANYWAYS...

 RAINBOW ROOM, WEST HOLLYWOOD, CA

JOE'S GENERIC BAR, AUSTIN, TX

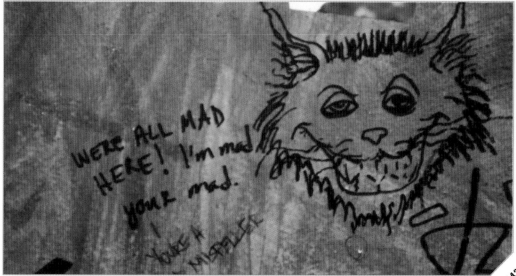

WE'RE ALL MAD HERE! I'm mad. your mad.

YOU'RE A MISSPELLER

"I really enjoy having Attacks where the I start getting these og strange urges to kill" sg louety club

 CAFÉ ESPRESSO ROMA, LAS VEGAS, NV

ABSINTHE BAR (CORRIDOR), NEW ORLEANS, LA

BEVERAGES DURING PREGNANCY MAY CAUSE MENTAL AND PHYSICAL BIRTH DEFECTS

Fetal Alcohol Syndrome — look it up
I teach children with this disorder.

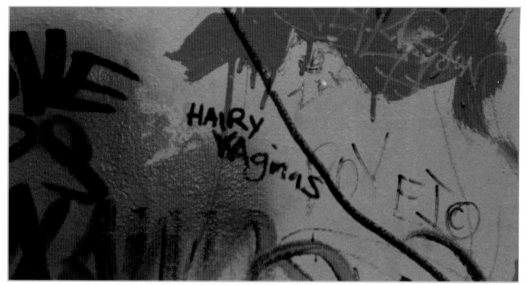

 LIL JOYS, ECHO PARK, CA

CALARTS (CORRIDOR), VALENCIA, CA

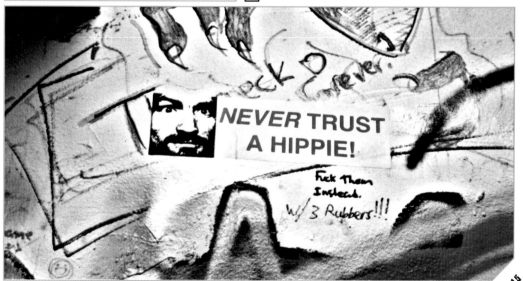

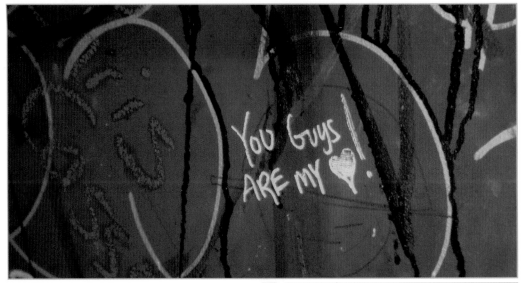

 THE DARK ROOM, NEW YORK CITY, NY

UPPER DECK TAVERN, CHARLESTON, SC

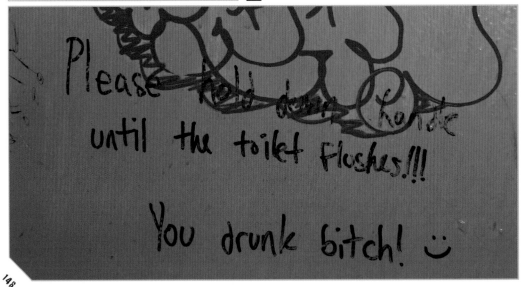

KurA
Cobain
did not
kill himself —
and I'm
Ov…

BS.

LOSE
WEIGHT...
YOU'RE FAT!... and tacky.

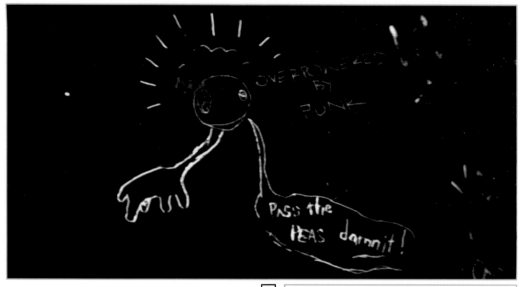

 CSULA, EAST LOS ANGELES, CA

CHE CAFÉ (CORRIDOR), UC SAN DIEGO, CA

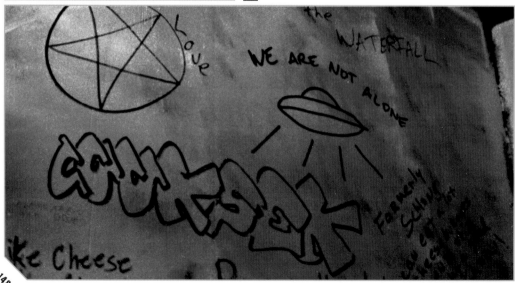

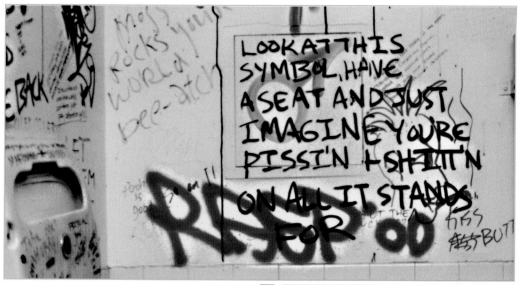

 CALARTS, VALENCIA, CA

SICAS PIZZA, NEW YORK CITY, NY

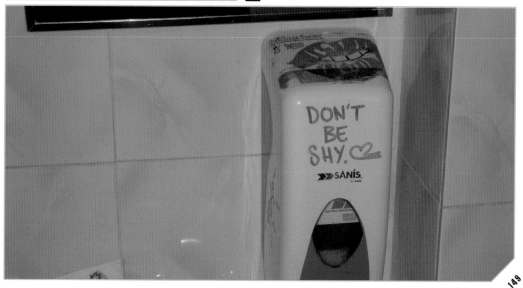

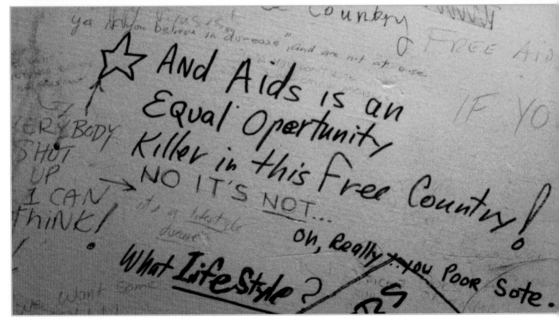

BOTTOM ROW (LEFT TO RIGHT): HIGHLAND GROUNDS, LOS ANGELES, CA; ZANZIBAR, PACIFIC BEACH, CA; HIGHLAND GROUNDS, LOS ANGELES, CA

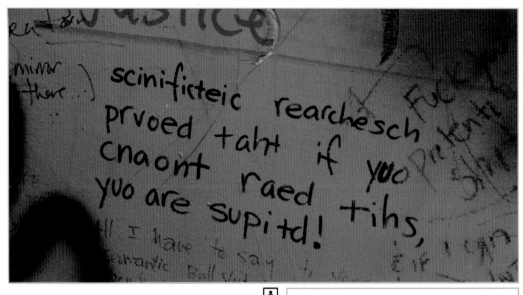

scinificteic rearchesch prvoed taht if yuo cnaont raed yuo are supitd! yuo

 LIL JOYS, ECHO PARK, CA

BARCADE, BROOKLYN, NY

I will never love you as much as I love beer.

♡ FALSEHEART

BRIDGET

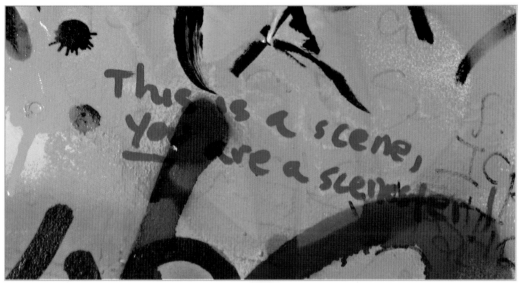

 KARMA COFFEEHOUSE, HOLLYWOOD, CA

UPPER DECK TAVERN, CHARLESTON, SC

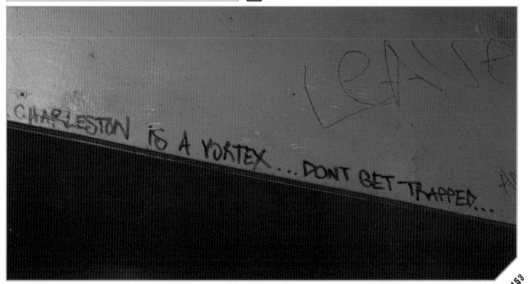

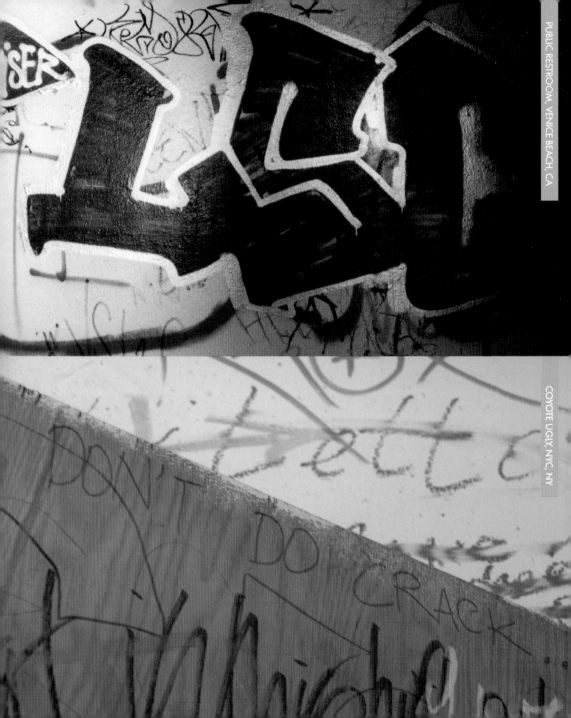

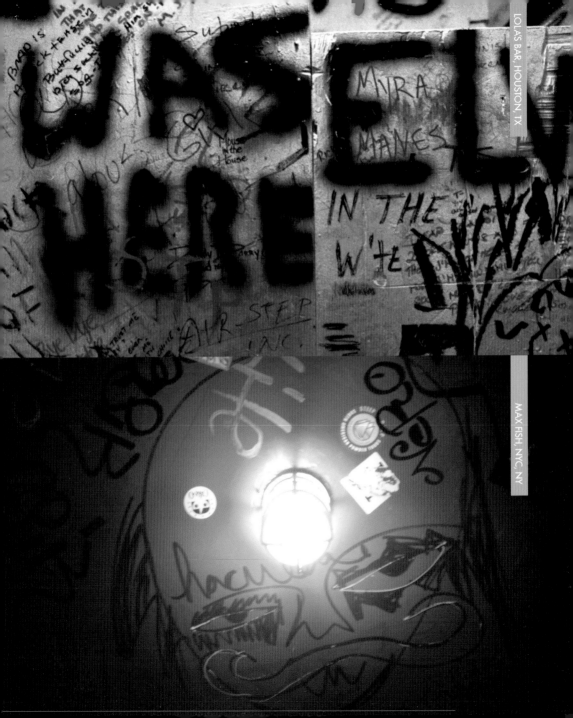

DEDICATED TO:
MY PARENTS LUPE RIANO AND JOHN FEREM
UNCLE FRANK RIANO
MY GRANDPARENTS
JULIA MAGANA AND MARCOS RIANO
ISABEL RODRIGUEZ AND SIGARD FJAREM

Acknowledgements:

The act of assembling this body of work was made possible by many and it's impossible to mention them all. With great respect to the presence of all the authors and artists that saw it in themselves to write, draw and share their moments of inspiration, I thank you. To all the aquaintices along the way that pointed me in the right direction of bathrooms crushed with graffiti, to all the establishments a heartfelt thank you. There are countless blogs. I would like to thank a few of you for blogging Latrinalia.org, Michael of del.icio.us/mquick, Regine DeBatty of "We Make Money Not Art", Chris from Cynical-C, Bianca Bueno of Bibi's box, Robb Todd of Graffiti Paparazzi and Yuki of kissui.net. Also I would like to thank the photographers Liz Berg of Brooklyn, NY, Kate Dalgleish of Calgary, AB, Canada and Andrés Felipe Uribe Cárdenas of Bogotá DC Colombia, South America. who sent in a few of their wonderful images. Also, huge thanks to Mark and Cynthia Batty for publishng the title, Editor Buzz Poole for his craft of the word and Christopher D Salyers for his design aesthetic.

A special thanks to Mike Tucker, Amir Fallah of *Beautiful Decay Magazine*, Adrian Zaw, Russell Emanuel, Cory Forsyth, Gabriel Morales, Lalo Juarez of *Buzuca Magazine*, and Dr Renata Plaza Teixeira for her inspiring soul, To my friends Jesus and Donna Felix, Randy Barnwell and Miho Murakoshi, John Castillo and Polly Mahvrin, Steve Morris, James Knight, Jessica Pappas, Axel Theil of International Work-Group on Graffiti Research, Anthony Ledesma and Rudy Villa. I would also like to thank Jean Chen of *Pop & Politics*, TooTall Jamal and UnitOne of Los Angeles 50mm, Jason Maggio at *Vapors Magazine*, JohnQ of Anti-Market, Marc and Sara Schiller of Woostercollective, and Stephanie Houseal of *Los Angeles Journal* for their support. Last but not least my sisters Loretta, Lorraine, my cousin Mikeal Fjarem, Sister Cecilia, my brother in-law Joe Dominque, John (and his wife Tammy) and all my extended family around the planet, thank you.

All photos by Mark Ferem except for the following:
Luís Augusto Barbosa: Page 39 (bottom).
Liz Berg: Pages 59 (bottom), 125 (top), 152 (bottom).
Andrés Felipe Uribe Cárdenas: Page 115.
Kate Dalgleish: Page 123.
DETACH: Pages 7, 32-33, 34, 35 (top), 59 (top), 67, 80 (top), 82 (bottom), 86 (top), 88-89, 92 (bottom), 94-95, 109 (top), 129 (top), 146 (top), 149 (bottom), 155 (bottom).
John Putnam: Pages 29 (top), 35 (bottom), 42, 43 (top), 44-45, 49 (top), 69 (bottom left), 86 (bottom), 87.

Bathroom Graffiti
by Mark Ferem

Design/Production: Christopher D Salyers
Editing: Buzz Poole

This book is typeset in Tempo Medium Grunged, Battery Park and Smack.

Examples from Allen Walker Read's "Classic American Graffiti: Lexical Evidence from Folk Epigraphy in Western North America" reprinted with permission from Maledicta Press, PO Box 14123, Santa Rosa, California, 95402.

Library of Congress Control Number: 2006932304

Printed and bound at The National Press, Hashemite Kingdom of Jordan

10 9 8 7 6 5 4 3 2

This edition © 2007
Mark Batty Publisher
36 W 37th Street, Penthouse
New York, NY 10018
www.markbattypublisher.com

ISBN-10: 0-9772827-4-0
ISBN-13: 978-09772827-4-6

Distributed outside North America by:
Thames & Hudson Ltd
181A High Holborn
London WC1V 7QX
United Kingdom
Tel: 00 44 20 7845 5000
Fax: 00 44 20 7845 5055
www.thameshudson.co.uk

MEN

BAÑOS

W

XY
ZW

GENTLEMEN

CLOSED
FOR CLEANING

LADIES

RESTROOM

RESTROOMS

CABALLEROS

Ladies